Photoshop

Absolute Beginners Guide to Mastering Photoshop and Creating World Class Photos

Andrew Mckinnon

Andrew McKinnon

Andrew McKinnon

Table of Contents

Introduction

Thank you for buying this book. I am sure this book will prove to be highly beneficial for you and your family, friends or colleagues.

Although many different photo editing software exist in the market, Adobe's Photoshop still holds a very important place due to its user friendly appearance, relatively simple to learn interface and versatility. It also holds a prominent place because it is very popular amongst people and everyone is accustomed to it.

A lot of people learn Photoshop for a variety of reasons. Some decide to learn it for improving their job prospects, others who want to venture into graphic designing, artists

who want to edit and retouch their artworks, photographers who want to edit their photographs to give them that special touch etc. Photoshop is very versatile and thus can help all of the above and more.

If you haven't already got the software, you can download a 30-day trial from the Adobe site. You can try it and then purchase the software if you want. Ideally it is always better to try something before buying it so I urge you to download the trial first.

Now if you have got Photoshop, the one thing that stands out is it looks much more complex and intimidating than the MS Paint application. Don't worry; all of these tools, windows and menus are there to help you and to make beautiful art. In this book I will try to explain all the basics that will get you started with your graphic designing journey in no time. Some of the basic lessons can be used for other photo editing software as well, making this book a multiplatform guidebook.

If you still feel intimidated by Photoshop, don't worry, by the end of this book you will realize that Photoshop is really fun

and it will ultimately become one of your favorite pastimes. As it is very versatile and the options to do things are unlimited you can create new artwork each time you open Photoshop.

For the convenience of the learner, each chapter of this book includes keyboard shortcuts together with the menu bar option. Initially, you may get confused by these shortcuts, but later on you will come to love them as they make Photoshop faster and more convenient to use.

This is a guidebook, and ideally you should not read it in isolation. Keep the Photoshop window open so that you can follow the guidelines and information given in this book. You should also try out the instructions given in the book as you read them to help understand the various different controls.

Lastly, once again thank you for buying this book. I hope you will fall in love with Photoshop by the end of it.

Andrew McKinnon

Chapter 1
Basics: The Interface

When you open Photoshop obviously the first thing you see is the software interface. As mentioned earlier, the interface and appearance of Photoshop can seem to be intimidating for people who are only accustomed to simpler applications such as MS Paint etc. But yet again, all these tools, windows and menus are for your own benefit. Let us now have a closer look at the interface, or Work Area, of Photoshop.

Menu Bar

The Menu Bar is the first thing you will see when you open the application. It sits right there at the top of the application. The Menu Bar of Photoshop is like the Menu

Bar of any other application; it has many menus organized by topics. There are menus such as File, Edit, Image, Layer, View, Window, etc.

Option Bar

The Option Bar is the bar right below the Menu Bar. It has a variety of options that change according to the tool that is selected. These options are varied and are used to manipulate the tool according to ones used.

Toolbox

The Toolbox is definitely an important aspect of Photoshop, it contains all the tools that are used to create and edit images. Some of the major tools will be explained later in this book.

Palette Well

The Palette Well is an interesting option that will help you to organize your palettes in your work area.

Palettes

Palettes are the various options that can help you to not only monitor your images but also modify them.

This is a major part of the Photoshop interface. In the following chapters various tools, palettes etc. will be briefly discussed.

Andrew McKinnon

Chapter 2
Toolbox

The toolbox is a rectangular box, which is normally located on the left-hand side of your application. You can move it around if you want. The Toolbox has many options and some of these options have sub options too.

Now let us take a look at some of the most important Photoshop tools.

Marquee Tool (Keyboard= M)

The Marquee tool helps make selections on an image file. It is available in rectangular, single row, elliptical and column selections. Its icon looks like a dotted rectangular shape.

The Move Tool (Keyboard= V)

The Move tool is used to move layers, selections, guides etc. It has the appearance of a black arrow with a four point moving sign.

The Lasso Tool (Keyboard= L)

The Lasso tool is another selection tool that is used to make selections like polygonal, freehand, magnetic etc. It looks like a lasso.

The Magic Wand Tool (Keyboard= W)

The Magic Wand automatically selects all the similarly colored areas. It looks like a wand with a star at the end.

The Crop Tool (Keyboard= C)

The Crop tool is used to trim images. It looks like the classic crop tool.

Slice and Slice Selection Tool

The Slice tool is used to create slices while the Slice Selection tool is used to select the slices. These two tools both look like knives.

The Healing Brush Tool (Keyboard= J)

The Healing Brush tool looks like a Band-Aid and is used to paint with samples or patterns, which can be used to repair problems in an image.

The Patch Tool

This tool is used to repair large areas. Its function is almost like the Healing Brush tool. It looks like a patch.

The Brush Tool (Keyboard= B)

The Brush tool is used to paint a variety of brushstrokes. It looks like a brush.

The Pencil Tool

The Pencil tool is used to paint hard and edgy strokes. The icon looks like a pencil.

The Clone Stamp Tool (Keyboard= S)

This tool is used to paint with a sample selection of an image. You can literally pickup a copy of a portion of an image and paint with it. It looks like a stamp.

The Pattern Stamp Tool

This has a similar function to the Clone Stamp Tool.

The History Brush Tool (Keyboard= Y)

This tool can paint a copy of any selected state, or take snapshots into a current image window.

The Art History Brush Tool

This tool can paint with a stylized stroke that simulates the look of different styles with the use of a selected snapshot or state.

The Magic Eraser Tool

This tool is used to erase solid colors to make them transparent. It looks like an eraser with a sun.

The Eraser Tool (Keyboard= E)

The eraser tool can be used to erase pixels. This restores the picture to its previously saved state. The icon looks like a rectangular eraser.

The Background Eraser Tool

This tool looks like an eraser with a pair of scissors. This tool can be used to erase background.

The Gradient Tool (Keyboard= G)

The Gradient Tool can be used to create creative blends between many colors. These blends can by radial, straight lined, diamonds, angled etc.

The Paint Bucket Tool (Keyboard= G)

The paint bucket tool is used to paint similarly painted areas with one color.

The Blur Tool

The Blur tool is used to blur edges. It looks like a drop.

The Sharpen Tool

The Sharpen tool is used to sharpen edges. It looks like a triangle.

The Smudge Tool

The Smudge tool can be used to 'smudge' the image. It looks like a finger.

The Dodge Tool and Burn Tool (Keyboard= O)

Andrew McKinnon

The Dodge tool is used to lighten the portions of a photograph, or image, while the Burn tool is used to darken an area.

The Sponge Tool (Keyboard= O)

The Sponge tool can change the saturation of the selected area. It looks like a basic sponge.

The Path Selection Tool (Keyboard= A)

The Path Selection tool is used to create shapes or segments to make selections.

The Type Tool (Keyboard= T)

This is used to add text on an image. It looks like a giant T.

The Type Mask Tool

The Type Mask tool is used to make a selection of a shape in the text.

The Pen Tool (Keyboard= P)

This tool is used to make smooth selections.

The Custom Shape Tool (Keyboard= U)

This tool is used for adding custom shapes from lists. These include many different and commonly used shapes.

The Annotation Tool

This tool is used to add annotation to the image. It can be in text or audio format.

The Eyedropper Tool (Keyboard= I)

This tool can be used to pick up sample of colors from an image.

The Measure Tool

This can be used to measure angles, distances etc.

The Hand Move and Zoom Tool (Keyboard H and Z respectively)

The Hand Tool can be used to move an image while the Zoom tool can be used for magnifying or reducing the view of an image.

So far we have covered nearly all of the tools in Photoshop. You will notice that some of these tools aren't visible in your application. Don't worry, just click on those little black

arrows next to some of the tools to activate the other tools. It is important that you try using all these tools multiple times so that you understand their uses thoroughly.

Now let us look at how to manipulate the tools with the help of the Tool options bar.

Nearly all of the tools in the toolbox have many options that can be manipulated from the tool options bar. These options change as per the tool, although some of the tools may have similar options as well. This bar can be moved all over as well. There are many options available, and describing each in a book that talks about the basics will not be a good thing. However, you should definitely try experimenting and using each of these options one by one. You will soon learn many tips and tricks by yourself.

In the next chapter we will have a look at palettes.

Chapter 3
Palettes

When you open Photoshop the many small windows that you see on your right are palettes. These can be used for many purposes, including navigation, adjustments, switching between modes etc. Below is the explanation on the most important palettes.

Layers

Layers are literally layers of a document. The layer feature can be used to edit and make changes to a document without changing the original. This feature is also used to add an interesting effect to an image.

The Layers palette is where you can find all of your layers. This palette allows you to arrange and organize layers, to set blending modes, change opacity, visibility etc. You can also merge layers, group them etc. Don't worry if you find this confusing and intimidating now, you won't when you become more experienced with Photoshop.

Adjustments

In this panel you can make and edit adjustments layers. These layers are layers that are used to do image alterations, which can be used to change various details. Normally this is used for color correction, but can be used to change other details as well, which can change the look of your image thoroughly.

Color Channels

The color channel palette can be used to look at the specific colors that make up your image. These colors can be viewed in many options such as RGB mode, CMYK mode, or LAB mode etc. This projects the various lights that your image has. You can use it to do touch ups, contrast enhancements etc. You can also use this option to make your photo black

and white albeit in a proper and professional way so that it looks stunning.

Color Picker

The color picker option can be used to choose colors with the help of an easy to use slider. Find perfect tint, or shade of your choice with this.

Color Swatches

These are a variety of swatches with pre-defined colors that can be used to choose from quickly. You can download many swatches online, or can make your own custom swatches too.

History

The History palette is like an extensive undo tool. You can go back in time to undo any changes that you do not find okay. The history panel allows to you to go to very far back in time. The default stats for the History palette are 50 actions but you can change it too.

Text

The text palette can be used to change the, edit or alter any text, which has been created with a type tool. You can make a lot of adjustments with this palette. The options available are very much similar to the options found in a word processor.

These are the palettes that can be used to edit and adjust your images. In the next chapter we will look at the various menus present in Photoshop in brief.

Chapter 4
Menu Bar

The Menu Bar contains various menus as explained in the brief introduction above. Most of the tools and options available in Toolbox and Palettes can be found in the menus as well, but there are some options that cannot be found in the toolbox. Let us have a look at few of these one by one:

File

This menu contains basic options that are common in every File menu such as Exit, Save, Open etc.

Edit

Like every other Edit menu this contains options like copy, cut, paste etc. You can also find options to transfer layers, or set color spaces too.

Image

In the Image menu you can find many options that can be found in the adjustments palette as well. These options can be used to alter the image completely. You can also choose to apply these adjustments to specific layers.

Layer

The options that are available in the Layers palette can be found in this menu too. You can also find many other options in this menu. You can create smart objects as well as create adjustment layers from this menu.

Select

The Select menu can be used to refine your selections, or put in the criteria for your selection. These criteria include color range, luminosity etc.

Filter

The Filter menu contains a variety of pre included and downloadable filters that can be used to edit a picture. These include sharpen, blur, distort etc. You can either alter your image, or your layer, with these filters. The best way to learn and understand what these filters do is to experiment with them. It is very interesting and fun to play with these.

Analysis

The Analysis menu has measurement tools. You can use these tools to make alterations that are accurate. This is an advanced option.

View and Window

In these menus you can find View options. It can be used to hide or show toolbox, palettes, line guides, edges, grid etc.

So far we have covered the tools, palettes and other options that are important to understand Photoshop. After this chapter we will look at certain simple alterations that you can start experimenting with right away.

Andrew McKinnon

Chapter 5

Basic: Touch Ups, Color Corrections and Enhancements

We have seen the basics apparatus of Photoshop; now let us use these tools to do some simple tasks in Photoshop. These methods and tasks are very simple, but also very effective and can give you wonderful results. The techniques mentioned in the title are in a way referring to the same thing. In this segment I will show you how to use some basic tools and palette functions to edit your image.

Color Correction

Color correction is easy and can cause dramatic changes to your photographs. You just need to have a certain taste and

an eye for colors and should understand which colors are complimentary and contrasting. Basically you should always focus on understanding the dominating colors in a photograph and identifying their location.

This can easily be done by anyone with a little practice. You can also use a histogram to do this, but it is slightly time consuming as compared to the naked eye. To use the histogram go to the Window menu and click on Histogram. The left side in this new window represents shadows, the middle one midtone and the right one highlight. You can easily see the dominating color in this new window.

When you are experienced enough to find out the dominating color, you can move to the next step.

Photoshop has many good color balancing tools available out of which nearly all can be found in the Image menu, toolbox, palette etc. Now let us look at some of these options one by one.

Color Balance

Although quite useful for minor adjustments this tool is not as flexible as the other tools or options available. It can be used to make quick and superfast adjustments. If you want to adjust a selective portion of your picture you just need to select the portion and then move the sliders accordingly. You can also create very interesting and sometimes even funny effects with this option. As said earlier, much better and effective options exist, but this is a very fast and quick option so use it if you are low on time and need editing done fast.

Levels

Levels are one of the most versatile options of Photoshop. You get three main sliders in the Levels option and a shadow slider as well. You can move the shadow slider to adjust the shadows. Left increases the intensity of the shadows while right increases the intensity of the highlights. In the middle there is a midtone slider which, if moved to the left can brighten your image and if moved right can make it darker. These sliders have an effect on contrast and are thus contrast affecting sliders. The sliders mentioned under the Output section affect brightness. If the black slider under this

section is moved to the white section it will brighten up the image, while to the black side will make it dark. These effects generally affect the complete image, but you can also choose to apply these effects to certain portions of the image. If you select specific colors from the dropdown list above you edit that color exclusively.

Curves

Curves are the most versatile, useful and brilliant color modification tools available in Photoshop. This tool has many options and thus you may find it intimidating, if you do it is better to stick to Levels for a while, if not then continue.

Curves basically works like Levels, except in this one you have to make your own points instead. To make a point, click at any point of the line and drag it in the direction you want. Try experimenting with the dragging.

Auto Tone

This is by far the simplest way of adjusting the colors of an image, but it is not extremely good. Click on Auto Tone which is available in the Image menu, the application will try

to guess what adjustments your image needs and will edit your image accordingly. If you don't like the changes made by the app you can always revert them.

Photo Retouching

In this part of the book, we will look at topics such as how to correct simple errors in photographs and to make them look better and crisper.

The best and easiest way to touchup a picture is by using the Healing Brush tool. There are also alternatives available to this tool such as the Spot healing tool, the red eye tool etc., which can be used to heal your pictures. Try using these tools on an image.

Enhancing an Image

You can enhance images with a lot of options in Photoshop. Enhancing an image is an art; you don't want to enhance an image in such a way that the image will look unrealistic or fake. It should look natural, normal yet beautiful.

Color Channels

To enhance a portrait you can use the Color Channels option. You can find this on the right side of the workspace in the Color palette. If you have selected RGB you will see four options in the window. You can try using and manipulating all of these. You will soon devise a way to use these effectively. You should use layers while doing this so as to keep the original image okay. You can also use the new layer to change the opacity of your image to create a very interesting effect.

Burning and Dodging

The Burn and Dodge tool act as virtual makeup tools, along with smoothening tools. You can use these tools to create shadows, highlights and contrasts to make your portrait more attractive. As this technique is very subtle you can use it to enhance a male or female portrait. These alterations may seem small but the effect created by them will be really dramatic.

In this chapter we saw how some basics tools in Photoshop can be used to edit an image, a portrait etc. These changes

can really cause dramatic changes and can make a simple image look beautiful and attractive.

Chapter 6
Drawing

In this chapter you will understand and learn the use of Shape tools, the erasing tools, the Brush tool and many other drawing tools. You can create very beautiful drawings in this application although not at the level of a specially made drawing program. Be sure to use only Vector images in order to keep the quality of you image.

Shape and Line Tools

The Shape tool in Photoshop can be used to add geometric shapes to an image. These are vector images. You can find the Shape tool in the toolbox, where there are shapes such as polygons, ellipses etc.

Another similar tool is the Line tool. You can use the tool to draw lines of various thicknesses and colors.

There is also an option of adding custom shapes to your image. This function can be used to add a watermark etc. to your photographs.

Brush tools

The Brush tool is a very versatile tool in Photoshop. It has many options and modes and thus is a multiple tool within a tool. You can use this tool to paint mild strokes in an image. The brush tool has many options that can be manipulated from the tools option bar. You can change the brush style, the flow of the brush, the opacity of the brush as well as the brush size. Some brushes can even be used as a stamp to create unique pictures and images.

Pencil Tool

As mentioned earlier, this tool is used to draw hard lines on an image. This tool becomes really versatile when used with a graphic tablet. You can then use this tool to sketch like you normally sketch on a paper. The Brush tool can be used instead of the Pencil tool, but the Pencil tool is much more

delicate and pointed. Unfortunately it cannot be used that effectively with a mouse which is why people who want to use the Pencil tool generally prefer a graphic tablet or stylus.

Paint Bucket

The Paint Bucket tool can be used to fill an area in the foreground with a pattern or a color. The Paint Bucket tool has many options to choose from which can be used to enhance and manipulate the properties of your image.

Gradient Tool

The Gradient tool can be used to fill in gradient in the foreground, such as a custom shape etc. You can select the desired options from the option bar. You can select a variety of color options from the option bar including rainbow etc.

Eraser

The Eraser tool erases a pixel in your image. If the image has only one layer then the image will be erased. But if used with multiple layers, the eraser tool reveals the layer underneath thus creating very artsy and interesting effects. You can also edit the opacity, flow, etc. of the eraser.

In the mode option of the eraser you can choose from three different modes. These modes are Brush, Pencil and Block. The block mode makes the eraser a fixed, rectangular shaped eraser.

Chapter 7
Filters

We talked about filters briefly in the introduction. In this chapter let us look at the most common filters and where they are available and where they are not.

Following are some common filters:

Artistic

- RGB- Yes

- Grayscale- Yes

- CMYK- No

- Indexed Color- No

- Bitmap- No

Blur

- RGB- Yes

- Grayscale- Yes

- CMYK- Yes

- Indexed Color- No

- Bitmap- No

B Strokes

- RGB- Yes

- Grayscale- Yes

- CMYK- No

- Indexed Color- No

- Bitmap- No

Distort

- RGB- Yes

- Grayscale- Yes

- CMYK- Yes

- Indexed Color- No

- Bitmap- No

Noise

- RGB- Yes

- Grayscale- Yes

- CMYK- Yes

- Indexed Color- No

- Bitmap- No

Pixelate

- RGB- Yes

- Grayscale- Yes

- CMYK- Yes

- Indexed Color- No

- Bitmap- No

Render

- RGB- Yes

- Grayscale- Yes

- CMYK- Yes

- Indexed Color- No

- Bitmap- No

Sharpen

- RGB- Yes

- Grayscale- Yes

- CMYK- Yes

- Indexed Color- No

- Bitmap- No

Sketch

- RGB- Yes

- Grayscale- Yes

- CMYK- No

- Indexed Color- No

- Bitmap- No

Stylize

- RGB- Yes

- Grayscale- Yes

- CMYK- Yes

- Indexed Color- No

- Bitmap- No

Texture

- RGB- Yes

- Grayscale- Yes

- CMYK- No

- Indexed Color- No

- Bitmap- No

Video

- RGB- Yes

- Grayscale- Yes

- CMYK- No

- Indexed Color- No

- Bitmap- No

Chapter 8

121 Top Photoshop Tips and Tricks

While Photoshop is an easy tool to use, it is quite another thing to master it. When you first start to use all the different features it can seem quite overwhelming, and you may struggle to get the right effect on your images. Help is right here as, in these last few chapters, I am going to give you a comprehensive list of tips and tricks that you can use to create a professional showpiece. Whether you need to know how to add layers, use the pen tool, how to manipulate RAW images or are looking for ways on improving your brushwork, I have all the answers for you here.

Kaleidoscope Patterns

Using a simple keyboard shortcut, you can create some amazing rotating patterns with your images. Simply press **Cmd/Ctrl+Shift+Alt+T** to produce a duplicate layer and transformation in one hit. You can use any image, shape or any particular effect you want to create this. To rotate the image first, press **Cmd/Ctrl+T**, turn slightly and then press Enter. Follow that with **Cmd/Ctrl+Shift+Alt+T** and keep repeating these two commands to create your pattern.

Combine Images and Text Together

This is really quite a simple thing to do – place an image over the top of your text. Use a type layer and drop your chosen image over the top of it. Hold **Alt** and click on the line that is in between the two layers in the Layers panel and the image will be clipped to the text.

Create a Bird's Eye View

Bring up the image of your choice on the screen, and zoom into a close up of a specific area. Now hold **H** and drag in the picture – this will dart you instantly out to a full screen, and then you can jump back to another area. This is great way of

Andrew McKinnon

inspecting your Photoshop work and seeing just how perfect it is!

Quickly Create Full Layer Masks

Locate the Layer Mask icon and press **Alt** while clicking on it. This will give you a full layer mask that hides everything that is on the layer.

Make Easier Marquee Selections

Press the **Alt** key while using any marquee tool – start your selection at the center point and then hold down the **Space** bar to move the selection around temporarily.

Create Funky Backgrounds

If you want to get rid of the boring default grey background and create something a little funkier, it's pretty easy to do. Simply hold down **Shift** while clicking on the background, using the paint bucket tool, and fill it up with the color you are using in the foreground. To put it back to grey, simply right click on it with your mouse.

Change the Number of History States to 1,000

Andrew McKinnon

inspecting your Photoshop work and seeing just how perfect it is!

Quickly Create Full Layer Masks

Locate the Layer Mask icon and press **Alt** while clicking on it. This will give you a full layer mask that hides everything that is on the layer.

Make Easier Marquee Selections

Press the **Alt** key while using any marquee tool – start your selection at the center point and then hold down the **Space** bar to move the selection around temporarily.

Create Funky Backgrounds

If you want to get rid of the boring default grey background and create something a little funkier, it's pretty easy to do. Simply hold down **Shift** while clicking on the background, using the paint bucket tool, and fill it up with the color you are using in the foreground. To put it back to grey, simply right click on it with your mouse.

Change the Number of History States to 1,000

50

To change the number of History States to a maximum of 1,000, click on **Edit, Preferences** and then **Performance.** Do be aware that this will have a somewhat detrimental effect on performance.

Organize Layers with Color Coding

You can organize your Layers panel by using color-coding. With your mouse, right click on the eye icon next to your selected layer and you will be given a choice of eight colors. Choose one and move on to the next.

Close All Open Images at Once

If you have several windows open and want to shut them all down easily, press the **Shift** key while clicking on the Close icon in any of the windows.

Spring Load the Move Tool

While you are using any tool, hold down **Cmd/Ctrl** and switch over to the Move tool temporarily. To go back to the tool you were using previously, simply release the keys. This tip will work for other tool shortcuts as well.

Interactive Zoom

Hold down **Cmd/Ctrl+Space** and drag to the right for zooming in, or to the left for zooming out. The zoom will target where your mouse icon is located, making it one of the easiest and quickest ways to navigate your way around your image.

Make Instant Layer Copies

To make an instant copy of a particular layer, hold down **Cmd+Alt** and drag the layer.

Add Diffuse Effects

Using the Diffuse Glow filter can add a nice soft ethereal feel to highlights, especially if you combine it with desaturation. Press **D** to reset all the colors and then click on **Filter, Distort,** and **Diffuse Glow.** Don't overdo it, keep it reasonably subtle. When you have the right level, click on **Image, Adjustments,** and **Hue/Saturation** and lower the saturation level to complete the ethereal effect.

Undo More Than One History State

Pressing on **Cmd/Ctrl+Z** is the keyboard shortcut for undoing your last action. However, to undo more than one History State, press on **Cmd/Ctrl+Alt+Z.**

Cycle through Blend Modes

Provided you don't have a tool that has Blend Mode options settings, you can cycle through Blend Modes by using **shift** + or -.

Merge Layers

Use **Cmd/Ctrl+Shift+Alt+E** to merge a copy of all of the layers.

Move Through Workspace Backgrounds

Pressing **F** will allow you to cycle through all the workspace backgrounds.

Change Fore and Background Colors

Press **X** to change your background and foreground colors.

Reset Fore and Background Colors

Press **D** to reset your background and foreground colors back to black and white.

Change the Size of your Brush Tip

Press either] or [to change the size of your brush tip up or down.

Duplicate Selections or Layers

To duplicate a specific layer or selection, press **Cmd/Ctrl+J**.

Navigate around Image

Hold the **Space** bar to move your image around.

Hide or Show Tools

Press on **TAB** to show or hide panels and tools.

Transform Layers

Hold **Cmd/Ctrl+T** to transform a layer.

Merge Layers

Press **Cmd/Ctrl+E** to merge a selected layer down, or to merge a number of highlighted layers.

Save Image for Web and/or Devices

Press **Cmd/Ctrl/Ctrl+Shift+Opt+S** to save your image for web or device use.

Show Levels Box

Press **Cmd/Ctrl+L** to bring the Levels Box up.

Free Transform Tool

Press **Cmd/Ctrl+T** to open up the Free Transform tool.

Open up Curves Tool

Press **Cmd/Ctrl+M** to open the Curves tool.

Change Color Balance

Press **Cmd/Ctrl+B** to edit the color balance on your image.

Scale Images

Press **Cmd/Ctrl+Shift+Opt+C** to scale your image to a new state.

Clipping Mask

Press **Cmd/Ctrl+Opt+G** to create a clipping mask.

Fit Image to Screen

Press **Cmd/Ctrl+o** to fit your image to the screen size.

Increase or Decrease Text Size

Press **Cmd/Ctrl+Shift+>/<** to increase or decrease a piece of selected text by 2 points.

Increase or Decrease Text Size

Press **Cmd/Ctrl+Option+Shift->/<** to increase or decrease selected text size by 10 points.

Change Brush Size

Press]/[to change your brush size up or down.

Fill Selection

Press **Shift+F5** to fill a specific selection.

Change Brush Hardness

Press }/{ to increase or decrease the hardness of the brush.

Move to Another Brush

Press ,/. to go to the previous brush to the next brush.

First or Last Brush

Press </> to go to the first or to the last brush.

Move Layers Forwards

Press **Cmd/Ctrl+]** to bring selected layers forward.

Send a Layer Back

Press **Cmd/Ctrl+[** to send a layer back.

Send or Bring a Layer to the Bottom

Press **Cmd/Ctrl+Shift+[** to send a layer to the bottom of the stack.

Bring a Layer to the Bottom

Press **Cmd/Ctrl+Shift+]** to bring a layer to the bottom of the stack.

Converting Layer Styles

To gain better control of editing the contents, you can convert a Layer Style to a pixel-based layer. Simply add a style and then right click on **Effects;** Select **Create Layer**.

View A Single Layer

If you are working with multiple layers and you want to view one layer on its own, there is no need to hide all the others manually, simply hold down **Alt** and click the Eye icon of a

layer to make every other layer invisible. Hold down **Alt** and click again to reveal them.

Invert a Layer Mask

When you have added an Adjustment Layer, press **Cmd/Ctrl+I** this will invert the layer mask and will hide the effect. Paint over the image in white to reveal the adjustment.

Unlink Layers And Masks

You can move images, or masks, independently of each other – in the Layers panel, click the link in between the two thumbnail images. Highlight the one you want to move and then use the Move tool to position it.

Quick Copy

To copy a layer, mask or style, hold the **Alt** key down and drag what you want to copy.

Convert the Background

To convert the background layer to one you can edit, double click on the layer and click on OK.

Adjustments

Rather than editing a layer directly, use the Adjustment Layers. This will give you no less than three advantages – the ability to edit any time you want to, the ability to control the strength using Opacity, and the ability to use a mask to make it work.

Move Query

When you are using the Move tool, pick a certain point in the image and right click on it – you will see a list of all the layers that are under the point you are hovering your mouse over.

Panel Options

One of the most important boxes in Photoshop is the Layers panel, so it is vital it is set up properly for your requirements. Click the Fly out menu and choose **Panel Options** to choose different content and sizes of thumbnails.

Move Layers Up Or Down

If you want to move layers around in the stack in the Layers Panel, while seeing your image change, press **Cmd/Ctrl** and

press] or [. If you add Shift in to the mix, you can move the layer straight to the top, or the bottom of a stack.

Fill Shortcuts

To fill in a layer, or a specific selection, with background color, press **Cmd/Ctrl+Backspace**. To fill in with the background color, press **Alt+Backspace** or use **Shift+Backspace** to access the Fill options.

The 50% Grey Layer

One thing that could be useful in a number of situations is a new layer that is filled with 50% grey. For example, you can add texture, dodge and burn, or use it to manipulate a Lens Flare effect, all without causing any damage to your work. To create the 50% grey layer, create a new layer and then click on **Edit, Fill** and change the Blend Mode to **Overlay**.

Layer Group Shortcut

Layer Groups are one of the most useful tools, but forget about clicking the Layer Group icon. If you do, you will need to manually add layers to the group. Instead, highlight the

number of layers you want to add, and drag them to the Layer group icon or press **Cmd/Ctrl+G**.

Edit Multiple Type Layers

If you want to change the size, or font, on a number of Type Layers at the same time, press **Cmd/Ctrl** and then select the layers in the Layers Panel. Select **Type** tool and then change the settings that you will find on the Options bar.

Layer Mask Views

To toggle between seeing the mask and the image, press on **Alt** and click the thumbnail for the selected Layer Mask. To switch a mask on or off, hold down the **Shift** key and click on a specific one.

Select Similar Layers

To choose all layers that are similar, such as those of the same type or shape, highlight one and then click on **Select** and click on **Similar Layers**.

Change The Opacity

When you are not using one of the Painting tools, you can change the opacity of a layer by pressing on one of the

number keys – 1 is equal to 10%, 5 is equal to 50% and 0 is equal to 100%.

Quick Masking

You may already know about the Color Range option in the Select menu. But, were you aware that you could go to a similar command by using the Color Range button that is found in the Masks panel? Using this, you can make a mask very quickly by sampling colors, which can then be used to make a quick spot color effect.

Step-By-Step Blend Fire Effects

There are two ways to do this:

 a. Copying in the fire

Select a portrait image and then a generic fire image. Grab the **Move** tool and then put a check by **Auto Select**, then **Show Transform Controls.** Grab the first image, drag it to your portrait image, and then change **Blend Mode** to **Screen**.

 b. Position and Warp

Transform the fire layer by clicking on the bounding box. Now you can position the layer after resizing and rotating it. Right click on the mouse while you are in **Transform Mode** and select **Warp**, so that the fire wraps around the body in the portrait. Now press **Cmd/Ctrl+J** - this will copy the fire layer, then you can transform it again and repeat to build up the fire layer.

Right-Click To Get Contextual Menus

Almost every tool in Photoshop has a contextual menu that can be accessed by right clicking. This will show you the major controls of the tool and a number of very handy shortcuts as well. You also have Active – this is where you can right click and bring up different options.

Speedy Navigation

One thing that will hasten your workflow, and up your productivity is the ability to be able to move around your image and to zoom in and out of certain parts – Press Cmd/Ctrl+ to zoom in, Cmd/Ctrl – to zoom out, and to get into the Hand tool and move around your image quickly, hold down the Space bar.

Crucial Selection Shortcuts

When you are using any of the Selection tools you can hold down **Shift** to add to a layer. If you want to subtract from it, press **Alt**. To intersect your selections, press **Shift+Alt**.

Paste In Place

If you cut a selection and paste it to a new layer, Photoshop automatically puts that selection in the center of the screen. To paste it onto a new layer but retain the positioning, press **Cmd/Ctrl+C** to cut and **Cmd/Ctrl+Shift+V** to paste the piece in place. In a similar manner, you can hold down the **Shift** key while using the **Move** tool while you are dragging layers in between documents, to put them in the same position.

Hide the Marching Ants

To hide or show the Marching Ants around a selection, press **Cmd/Ctrl+H**. To do the same with a Path line, press **Cmd/Ctrl+Shift+H**.

Cmd/Ctrl+Click

When you want to load the contents or the shape of a thumbnail, Path or Channel as a selection, simply hold down **Cmd/Ctrl+click** when you are on any mask or layer thumbnail, or a Channel or Path.

Switch Lasso

When you are using the **Lasso** tool, you can temporarily switch to the **Polygonal Lasso** tool by pressing **Alt** and then letting go of the mouse button.

Fixed Ratio Selections

If you are using the Rectangular Marquee tool, you might be interested to know that it has a very useful Style setting, found in the Options bar, which allows you to make your selection at fixed size or ratio. This is particularly useful if you are looking to choose a certain area to be used as wallpaper or for a web page.

Transform A Selection

In the same way that you transform a layer, you can transform a selection. Simply open **Select Transform**

Selection and then right click to pick from transform modes, like **Warp** and **Skew**.

Pen Tool Rubber Band

If you have never used the Pen Tool on Photoshop, this is one the best tips that you will find. New users to the tool find it frustrating when they are plotting out anchor points, as you don't often know how the next curve is going to behave. A very useful feature is hidden away in the Options Bar, one that beginners will find a godsend. Click on **Geometry Options** (you will find it next to Auto Add/Delete) and then check the box next to **Rubber Band**. Now, when you use the Pen tool, an interactive preview of the next curve will appear before you add it in, giving you the opportunity to see how it will look.

Cropping Without Destroying an Image

The Crop tool has a little known about feature that lets you hide cropped areas, instead of deleting them. First, make your background layer by double clicking on it, and pressing OK to edit it. Then get the Crop tool, drag a window of a selection to crop and, instead of applying it, click on Hide in

the Options menu. You will now be able to recrop your images whenever you want just by dragging outside of the window to see the areas you cropped earlier.

Tweak Anchor Points

When you are using the Pen tool, you can hold down **Cmd/Ctrl** to switch temporarily to the **Direct** Selection tool. This will allow you to control handles and move your anchor points.

Add an Anchor Point

To add in a new anchor point, hover your mouse over the path line already there and the Pen tool automatically switches to an **Add Anchor Point** tool.

Remove Handles

If you want to get rid of handles from an anchor point and turn it into a sharp angle, press down **Alt** and click over the handle.

Change a Selection to a Path

If you want to change an active selection into a Path, simply click on the **Make Workpath** selection found at the bottom of the Path panel.

Add Handles

To add handles to a specific point. Hold down **Alt** and drag outwards from the anchor point.

Path Options

When you have made a path using the Pen tool, you can right click on it for a ton of options, including Stroke Path, Fill Path and Make Selection.

Magnetic Pen

If you want a magnetic Pen tool that acts in a similar way to the Magnetic Lasso, open the **Tools** panel and select **Freeform Pen**. Then in the Options Bar, click on **Magnetic**.

Step-By-Step: Select Sky With Channels

a. Copy Blue Channel

Go to the Window Channel and drag the Blue Channel over to the New Channel icon – this will make a copy of it. Now press **Cmd/Ctrl+L** to get into the **Levels** menu, and drag the sliders in to make the land pitch black and the sky completely white. Using the Brush tool, use black to tidy up any bits on the land.

b. Load up a Selection

Press down **Cmd/Ctrl** and simultaneously click the Blue Copy Channel. Add a selection of the white and then click on RGB Channel. Go to **Layers** and click on **Curves Adjustment Layer.** The white selection will automatically be transformed into a mask. Drag the curve down to darken up the sky.

Try Adobe Easel

If you own a tablet and want to edit images on it, Adobe Easel is a great way to do it. It is both a bit of a fun and a somewhat serious tool that gives finger painted brush strokes a fluid look that is very difficult to do on a computer. And, with Wi-Fi, transmissions between Photoshop and

your tablet makes the whole painting process much more streamlined.

Change the Angle of the Brush

If you are using a non-circular brush, you might find that you need to change the brush tip angle. Click on the **Brush** panel, found in the Options Bar, and then highlight the **Brush Tip**. Drag the circle and change the brush angle. You can also use the checkboxes to flip it vertically or horizontally.

Rotate The Clone Source

You can clone round corners simply by rotating the clone source. To do this, press **Shift+Alt+<** or **>**. It is more helpful if you check **Show Overlay** in the **Clone** Source panel, as this will allow you to see the rotation.

Add Real Paint Ridges

Digital painters often use the **Bevel and Emboss** filters so that their brush strokes can look like real ridges of paint. To do this, copy all layers and then merge them. Set **Blend Mode** to **Overlay** and then click on **Bevel and Emboss**.

Interactive Brush Settings

When you are using the Brush tool hold the **Alt** key down and click the right mouse button down to see a preview that shows you the size and hardness of the brush tip. To increase or decrease the hardness, drag up or down and, to increase or decrease the size, drag left or right.

Tilt Canvas

Photoshop tips and tricks are not all about shortcuts. Sometimes, when you are painting in Photoshop, it is far easier to rotate your canvas than it is to try bending your wrist, which can be extremely uncomfortable. In the same way as a person sketching on paper would change the angle of their paper, you can change the angle of the canvas by holding **R** and using the mouse to drag. Let go of **R** and you will go back to the original tool. To revert everything back to normal, hold **R** and then, in Options, click on **Reset View**.

Smudge Painting

This is an extremely satisfying way to paint. Simply fill up a layer with an off-white color and then duplicate the background layer. Set it to the top of the stack and set

Opacity at 13%. Select **Smudge** then check the box next to **Sample All Layers** and then you can begin painting.

Add Texture To Paintings

Try making your paintings look authentic by giving them a paper texture as a finishing touch. To do this, copy a texture over the top of your image and then get experimenting with different **Blend Modes** and **Opacity** until you achieve the effect that you want. Good results can usually be obtained with the **Darken** or **Multiply** modes.

Draw Straight Lines

You can use the **Brush** tool to draw a straight line by holding **Shift** and clicking two points where you want the line to be drawn.

Sample A Color

You can also use the **Brush** tool to select a set a sample of color as your foreground, by pressing down **Alt** and clicking on the color sample.

Precise Painting

To be more precise in your painting, you can press down the **Caps Lock** key to change your cursor to a crosshair instead of an arrow.

Cycle Through The Brushes

You can cycle through all the brushes by using, and to move left or right in the **Brush Preset Picker**.

Dodge or Burn

When you are using the **Burn** tool to paint with, if you press down **Alt** you will instantly switch to the **Dodge** tool.

Get A Pen And Tablet

If you like digital painting but you don't have a proper graphics tablet then you really are missing out on something special, namely a whole world of creativity. There are lots of decent tablets that are not too expensive, but if you are serious go for a mid-range one that has multi-touch input.

Change Brush Hardness

As you already know by now, to change the hardness of your brush, you use the] and [bracket keys, but did you know that you can also use **Shift+]** or [to do the same thing?

Change Opacity Quickly

If you press on any number between 0 and 9 when you are using the **Brush** tool, you can change the brush opacity. To adjust the flow, press down **Shift** and then a number.

The following tips are all about using RAW images.

Use Select All

If you want to batch process a whole bunch of images at the same time, open all of them up in ACR (use Adobe Bridge for this, it's much easier). Click on **Select All** and then select just one image and edit it with the changes you want made on all the open images.

Open Smart Objects

To open **Smart Objects,** in ACR hold down **Shift**. Notice that the **Open Image** button has now changed to **Open Object**. The file will now open as **Smart Object** and you will be able to double click on the layer thumbnail that is in Photoshop to edit the layer in ACR.

Mask Sharpening

In the **Detail** panel there is a **Masking** slider. This allows you to control areas of an image that need sharpening, but unless you hold down the **Alt** key while you drag the mouse, it is impossible to judge properly. Doing this will display a Grayscale view – in this, the dark areas cannot be sharpened but you will be able to see what can be.

Quickly Reset the Sliders

If you want to reset any slider back to 0, simply double click on it. Clicking once will move the slider to the point where your mouse cursor is. Keeping the mouse still, single click it and then double click to see a before and after look at any changes you have made.

Crop Ratios

To make your images stand out, use square crops. To see all the different crop ratios, hold the mouse button down over the **Crop** tool. Like everything else you do in ACR, cropping is not destructive so you will be able to try out all different ratios and play around with crop ratios at any time.

Exposure Before Color

Before you start making corrections to color on your images, it's best to adjust the exposure first.

Adjustment Brush Controls

One of the best ways for selective toning in ACR is to use the **Adjustment Brush**. This works by setting pins that are lined to painted masks that specify which area you are going to tweak. You will need to view the mask while you are painting and, when you use the adjustment sliders, you can hide the mask. To switch Mask view on and off press on **Y.**

Erase Parts of Masks

When you are using the Adjustment Brush, you can erase parts of the masks by holding down **Alt**.

Clip The Blacks

Because deeper blacks add a bit of a punch to an image, it is okay if you want to clip the black a bit. Hold down **Alt** while dragging the Black point slider inwards – you should see a few darks spots.

Straighten Horizons

To straighten up images, hold A down and drag a line.

Clipping Views

To view clipped pixels, hold down **Alt** and drag one of the sliders for Recovery, Exposure or Blacks. Alternatively, to see clipped pixels all the time, click on the icons at the top left and top right in the histogram.

Use Your Available Screen Real Estate

To make the most out of your screen size, press on **F** to switch from ACR to Full screen Mode.

3D Carousel View

If you are looking for ways to see your images displayed in a different way, click on **Cmd/Ctrl+B** and see your images displayed in a 3D carousel. You can use the arrow keys to scroll through the images and press the **Down** arrow to remove one from the view.

Paste ACR Settings

If you want to copy ACR treatments in Bridge, from one file to another, just **Right click** on one file with an ACR icon. Now go to Develop **Settings** and click on **Copy Settings**.

Andrew McKinnon

Now right click on another ACR file or, if you want to choose more than one, hold down **Cmd/Ctrl** and click on Paste.

Stack Images that are Similar

Stacking images can help to tidy up your workspace, and you will find it easier to move though them if you group images that are similar together. Choose a file group – hold.

Open All File Types In ACR

By default, RAW images will open in ACR, but you can also open other file types, like TIFF or JPEG, in ACR simply by right clicking on the file and selecting **Open in Camera RAW**. Alternatively, you could just press **Cmd/Ctrl+R**.

Open Groups of Images as Layers

You can open a group of images in a single document as layers by opening **Tools, Photoshop** and **Load files** into Photoshop Layers.

Step-By-Step Solarisation In ACR

 a. Create a curve that is cone shaped

In ACR, open an image and click on **Tone Curve Panel**. Delete the points off the curve by dragging them off and then create one single one in the center. Drag that point down and then drag on the bottom left to line it up with the top, creating an inverted cone.

b. Convert to mono

Now click on the HSL/Grayscale Panel and check the box beside Convert to Black and White. Manipulate the sliders to tweak the conversion to how you want it and, if you do want to add a little color, open Split Toning and adjust those sliders as well to add the color in to the highlights and shadows.

Create A Brush

You can make your own brush tip using any image of your choice. Convert the image to monochrome and make a selection from it. Open **Edit, Define Brush Preset**. You will see that only the dark parts are recorded; white bits are ignored. If you want a clear brush tip isolate the particular shape, or object, against a white background.

Make Sketch Lines

Adding sketch lines to an image you are turning into a painting can make it look more effective. First copy your layer and then open **Filter, Stylise,** and **Glowing Edges**. Desaturate, invert your colors and then use **Multiply Blend Mode** or **Darken**.

Experiment

Photoshop tips: Experiment!

In the Brush panel you will find hundreds, perhaps thousands of different brush settings and effects. The best way to find out what works and what doesn't is to open up a new document, grab a brush tool, pick a color and start playing!

Go Further

To take things even further, paint on different layers and experiment with different **Blend Modes**. You could even add **Layer Styles** to the layer you have painted.

Step By Step: Quick Brush Effects

 a. Set up the Brush

Open a portrait image, a generic one will do and then open the **Brush Picker** menu; choose **Square Brushes**. Select a particular brush and open up the Brush panel. Use the following settings:

- Brush tip shape – Spacing - 631%

- Shape Dynamics – Size – 100%, Angle – 100%, Roundness Jitter – 100%

- Scattering – Scatter - 638%, Count Jitter – 50%

- Color Dynamics – Foreground/background Jitter – 20%, Saturation Jitter – 20%

- Brightness - 30%

b. Paint mask and colors

Select the Lasso tool and then select the person from the portrait image. Press **Shift+Backspace** and click on **Fill: Content Aware.** Press **Alt** and select **Add Layer Mask** icon. Set the foreground color to white and paint the mask on over the figure to hide parts of the body. Now add an

empty layer and hold **Alt** down so you can sample different colors from the figure. Paint to add fragments of color. Add a new second layer, paint with larger strokes and then use **Filter, Gaussian Blur** to blur it all slightly.

Chapter 9

25 of the Top Tricks to Making Your Photos Look Professional

It is entirely fair to say that Photoshop has had an amazing effect on the world of design and is the number one choice of photo editing software in the world. It may not be the cheapest piece of software there is, but it is the best and it is the one that all of the professionals use – taking us from needing buildings full of labs and darkrooms and specialist equipment to just needing a good computer and Photoshop.

However, like anything, Photoshop can only be as good as the person who is using it, and if you are finding that you are struggling to do anything with your photos and feel like

you've wasted your money, you're not using it right. To help you, I've put together 25 tips that you should know about and that will help you give your photos that professional finishing touch.

Rounded Corner Frame

When we used to only use film cameras, some photo laboratories would print out the images and then round off the frame corners. With the age of digital cameras and software like Photoshop, this is dead easy to do these days. And you can use this with any shape:

- First duplicate the background layer.

- Next, choose the background layer and click on **Edit, Fill**. Use whatever color you want to show up as the image frame.

- Click on the **Shape** tool – it can be found on the toolbar – and right click it. Select the shape you want to use, for example, a rounded rectangle. The radius should be set to 30 pixels.

- Draw the frame on the image you have chosen and move it using the **Move** tool so it is in the right place.

- Grab the duplicate image layer with your mouse and drag it so it is over the shape layer – found in the Layers Palette. Press on **Alt** and click the layer to make a clipping mask and ply the frame to the image.

Give Your Image a Washed Out 70s Feel

A real photo will fade as the years go by, but it won't fade evenly across the whole spectrum of color. You can give your images that washed out old look:

- First you need to create a new Hue and Saturation layer.

- Change Blend Mode to Saturation.

- Open the Adjustment Window and check the box next to Colorize. Set Saturation to 15 and Lightness to -28.

- You need to lower the contrast levels, so make a new Curves layer over the top of the Hue and Saturation layer. Pinpoint the left point (in black) and raise its input to 0 and output to 20.

Miniature Effect

This is something that is doing the rounds on the Internet and has been for many years. Most of today's cameras have fixed sensor positions and lenses and, in creating this effect, you are duplicating what an image would look like if taken on a large format camera, with the ability to shift the way the lens sits. This makes the focus fall off below and above, and gives the impression that the image subject is rather small:

- First duplicate the background layer.

- Convert the layer for Smart Filters by clicking on **Filter, Convert for Smart Filters**. This will allow you to adjust the blur that you are going to add now.

- Go to **Filter, Blur** and apply a Gaussian Blur. Start off with a good amount, around 15 pixels.

- Now create a layer mask on the same layer by clicking on the Mask icon that you will find at the bottom of the Layers Palette.

- Click on the **Gradient** tool that is on the toolbar and change the gradient type to **Reflected** - this is the fourth icon from the left hand side.

- Now that the mask is selected, draw a line vertically from the center to the top of the image. The sharpest point will be where the line is started.

- Go back to the layer you added the Gaussian Blur to and either add or remove blur to make it a little better and more seamless.

Basic Liquify

One of the single most powerful control tools in Photoshop is the Liquify tool, which can be found under the **Filter** menu. This tool lets you push pixels around, stretch specific areas out, shrink certain areas, pull in a jawline and so many other things. This is the "airbrush" part to Photoshop and it's a tool that many a professional photographer uses on a

daily basis. In the Liquify window, you will see a panel on the left hand side and it is this that dictates what the brush does. If you hold your mouse pointer over each option, you can see a description of what they do. The first option, **Forward Warp**, is one of the most useful as it pushes pixels around – you dictate the direction with the mouse pointer. To change the amount and the intensity of the movement, you just need to change the size and the density of the brush you are using.

Shadow/Highlight Tool

This tool makes bringing out most details very quick and easy. To access it, click on **Image, Adjustments, and Shadow/Highlight**. By default, the basic settings will appear and there are just two sliders to use – one that helps to recover lost detail and darkening areas that are too bright, and the other works in the opposite way with the shadows. If you click on **More Options** you will get more detailed sliders – one called **Tonal Width Control**, which lets you control how much of the picture is considered within the shadows, and one called **Radius Controls**, which lets you control how much needs blending between the areas that are

affected and those that are not. There is also one for **Color Correction**, which lets you adjust for changes in color saturation, very important if you are making changes to the highlights. The **Midtone Contrast** is a simple adjustment slider for those bits that are in between the shadows and the highlights. That one's best used on images that have been taken at night using dark but even lighting.

Adding Fill Light

This is a little trick that uses the selections that are generated as adjustment layer masks from Channels.

- Open the Channel palette and press **Cmd/Ctrl+** and click on RGB Channel.

- Make a new Curves layer – using the selection to create a new layer mask automatically.

- Press **Alt+** and click on the selection – invert it by clicking **Cmd/Ctrl+I**.

- Press **Cmd/Ctrl+M** to apply a curve on to the mask.

- Locate and move the left point about one quarter of the way in, and then move the right point about three quarters in.

- At the moment, the mask is adjusted to midtones, so return to normal by pressing on the eye icon that you will find on the Curves layer.

Non-Destructive Workflow

What this means is, you won't be working on the background layer of the actual image. Instead, you add adjustment layers and more layers that are filled with Heal Brushed or Cone Stamped retouches, you are making the file size larger but you are never actually making any changes to the original. This is important if you intend to do more work on those files later on, especially if you want to print them or size them for the web.

Redeye Removal

- Open Layer, New Adjustment Layer and click on Hue/Saturation layer to create a new layer.

- In the Layers Palette on the new Hue/Saturation layer you just created, click on the Mask icon – the white box – and fill it with black by clicking on Edit and then Fill.

- Use a brush to paint over the red in the eye using white.

- Go back to your Adjustment Layer and change the affected colors to Reds – the current setting will be Master.

- Turn the saturation level down to 15% and remove shadows in the eyes by raising the lightness level.

Actions/Batch

The Actions Palette is a useful place to visit as it allows you to do so many useful things. One of these is to hit **Record**, make as many changes as you want to an image and then press **Stop**. You can then repeat the same process on any number of other images easily. This is very helpful if you need to resize a number of images, which you can do by clicking on **Image, Image size,** or if you want to change

Andrew McKinnon

the contrast levels in the same place on all images, for example. By clicking on **File, Automate** and then **batch** you can select a whole file full of images that you want to run recorded actions on.

Sizing Images for the Web

Photoshop contains its own automated program for resizing images:

- Open File, Scripts, Image Processor.

- Click on Select Folder and then navigate to the location of your files.

- Click on Save in Same Location. This will create a .JPG file inside the file you just clicked on – your smaller images will be saved in this folder.

- Click on Save as JPG and set the quality to 10. You can go as high as 12 but if you go any lower than 10, the pictures will be smaller, resulting in bad compression on the images.

- Click on Resize to Fit and put in 800 pixels for the width and the height. This will mean that the longest edge of the image is just 800 pixels, which is ideal for web use. You can go smaller if you choose though.

- Click on Convert Profile to sRGB. Most internet browsers are not capable of reading anything but sRGB, so this is the best choice if you want your images to translate correctly between screens.

- Click on Run and your images will be resized and saved in the new folder.

Best Camera Settings

This will depend entirely on the model of camera you are using but, as a best practice guide, the best settings for image capture are as follows:

- Adobe 1998 colorspace instead of sRGB, which is the standard for most point and shoot cameras.

- Shoot in RAW instead of JPEG, because the latter makes the file size smaller and loses the image detail.

- Use the lowest ISO setting you can to cut out noise caused by high sensitivities.

Hazy Lights

Give your images a dreamy kind of look by adding a haze around lights in the image. Combine this with a lower saturation level along with an amber cast and you get something close to summer dusk:

- Open the Channels Palette and then **Cmd/Ctrl+click** on RGB Channel. This will load up the brightness levels as a selection.

- Go back to the Layers Palette and make a new Curves layer. The selection is loaded automatically as the mask.

- Now **Alt+click** on the Mask icon, found in the Layers Palette. You will see a black and white version of the mask over the top of your image.

- Press **Cmd/Ctrl+M** to load a Curves adjustment. This will adjust the recently loaded mask. Drag the left point on the curve to the right, which will black out the entire image except for the brightest white parts. Click the Eye icon on the layer and go back to the normal view.

- Select the Mask and open **Filter, Blur,** and apply Gaussian Blur, set to 5 pixels.

- On the curve, put a point at about 80% and pull it up to brighten the area that surrounds the lights. The haze effect is added with the blurred layer mask.

Smart Filters

These were first introduced in Photoshop with version 4. The option **Convert for Smart Filters** lets you make changes to a previously applied filter. For example, if you converted a specific layer for smart filters and then put a blur on the layer. You can return to it and remove all or some of the blur without losing anything from the image. This does increase the size of your file quite significantly, but if you

intend to save the finished product as a .JPG, it doesn't really matter how large it is.

Catch-Lights

A catch light is just a reflection of light in the eyes of the subject in the image. If these are missing it makes the subject look lifeless, dead really. Putting them back in is a simple fix:

- Open **Layer, New Adjustment Layer** and tap on **Curves.** Create a new layer and fill the mask with black.

- Locate the top right point in white and drag it left from around 255 to about 180 – the point should now say output 180 and input 255.

- Zoom in to the eye that needs to be fixed and select a brush that is hard edged. Set it to 100% opacity and use just a quick light brush of white onto the mask. That will show up the curve adjustment you made before.

- If you want to add a good amount of light to the yes, add a glint of highlight.

Selective Color Matching

To create cohesion in the frame, match colors – for example, match up with the red in a lipstick to a red in wallpaper, or the blue in the sky to the blue in a subject's eyes. This works to simplify an image by getting rid of colors that aren't really needed and that results in a much tighter feeling to the image. This will vary between the images you use but most of your work can be done using an adjustment layer made up of Selective Color, Curves and Hue/Saturation. You can also help by changing the Blending mode to **Color**.

Old Flat Look

To give your images an old-fashioned flat look:

- First, open the Blue Channel from the Channel Palette by pressing **Cmd/Ctrl** and clicking on it.

- Create an inverted selection by pressing on **Cmd/Ctrl+Shift+I**.

- Create a Curves layer and you will find that the inverted selection will be turned into a mask, automatically, for the new curves layer.

- Go into the Blending mode settings for the layer and change from **Normal** to **Luminosity**. This will change the brightness of the colors but it will also stop them from moving.

- Add in two points on the curve – pull the left side down and the right side up, creating an S shape.

Channels as Masks

A Mask is nothing more than a filter on a specific part of a photograph, the part that is affected by an adjustment layer. The Channel Palette allows you to change color channels – red, blue and green in particular. This is helpful when you need to remove blue noise from the shadows on a night shot at a high ISO, or if you need to up the green intensity in a panorama shot.

Dodge/Burn

If you are looking to dodge (lighten) or burn (darken) certain parts of your images, it's fairly easy to do and you don't need a darkroom to do it:

- Open **Layer, New** and then click on **Layer**. Call the layer **Dodge/Burn** and then change the blend mode to **Overlay** – do make sure that the box beside **Fill with 50% gray** is checked.

- Choose the brush you want to use and reset the fore and background colors back to black and white – just press **D**. At the top of the screen, change the opacity of your brush to 5% - anything above that will be far too strong.

- Use white and paint on the Dodge/Burn layer to brighten up the highlights. You can darken them by using black if you so choose, but it doesn't turn out looking too good. It is far better to use the black for accentuating hair highlights or wrinkles on the skin and this is very effective in a black and white image.

Square Crop Theory

If you crop a photograph square, it will have an effect on the horizontal or vertical look to the photo. In a horizontal image, if the horizon is the dominating one, a person who is

looking at it will follow the line, and the same thing applies to a vertical image. If you crop your image square, the eyes wander because they don't have a true line to follow.

Vignette

- Open the Square Marquee tool and right click to select the **Circle Marquee** tool. Go into the feather setting and change it to around 200 pixels.

- Make a new curve layer – go into **Layer, New Adjustment Layer** and click on **Curve**.

- Make it darker by adding a point in the middle of the curve and pulling it down – darken as much or as little as you want.

Teeth Whitening

While it is fairly easy to remove yellow stains from teeth on photographs, it is easily overdone so take it easy with this and err on the side of caution:

- Open **Layer, New Adjustment Layer** and click on **Hue/Saturation** to create a new layer. Go to

the top of the palette and change blending from **Normal** to **Color**.

- Choose the white box that is beside the icon of the new layer, click on Edit, and then **Fill** to fill up with black.

- Choose the brush tool and then paint over the teeth you want to change in white. You won't see any changes just yet as you need to adjust the new Hue/Saturation layer first.

- Go back to that adjustment layer and change the affected colors from Master to Yellow. Lower the saturation level to around 15% and remove black by upping the brightness.

Amber Gradient

How many of you look for driving glasses with a good amber gradient in them? These are great because they add a somewhat summer-like tint to everything, no matter what the weather or where you are. You can do the same thing with your photographs:

- Click on your foreground color swatch and choose a color that is a nice amber color.

- Go to **Layer, New Fill Layer** ad click on **Gradient** to create a new gradient layer. Click on **Reverse** or rotate the layer by 90°.

- Change the blend mode for the gradient layer to **Color** and lower opacity to around 40%.

There you have it – an instant summer look.

Use the Clone Stamp and Healing Brush to Clean up Skin

If the surface blur just doesn't cut it for singling out a particularly bad area, use the Clone Stamp and Healing Brush to do the job for you. Here's how:

- Open **Layer, New** and **Layer** to create a new layer or use the shortcut **Cmd/Ctrl+Shift+N**.

- On the tools palette, locate the clone stamp – check that the sample menu says **Current and Below**. This will let you work over the top of the image

instead of directly on it, which makes it much easier to fix any mistakes you might make.

- The Clone tool is pretty much a Copy/Paste tool, but with a difference in that the copy is a relative distance from the paste area. Hold down **Alt** to change your cursor to a crosshair – this will be where you are copying from. Wherever you click after you do that will set the Copy and Paste distances.

- Soften up your brush and reduce the opacity so it smooths out a bit.

- The Spot Healing brush, on the other hand, is somewhat more detailed and helps to clean up the skin. Click on an area that you want to blend and use a bit of trial and error to get it right. The real key is using a brush that is soft edged.

Using Blue Channel Correction to Clean up Skin

This will help you to clean up blemishes and bad skin on images where there is a significant amount of skin on show.

It works because most of the imperfections will be picked up in the Blue Channel:

- First of all you must duplicate the background layer.

- Now open the Channels Palette and select Blue Channel by holding down **Cmd/Ctrl** and clicking the Mask icon.

- Next, select the duplicate you created and add a mask to it by clicking on **Add Mask** - the icon is at the bottom of the palette.

- Select **Filter, Blur** and click on **Surface Blur.** You don't need much here but do overdo it just slightly as you can adjust it through the layer opacity setting later on.

Grain

This will work much better if you use it on a monochromatic photo, or black and white that doesn't have too much detail in it. The grain adds in the illusion of detail:

- Create your new layer and change the blending to Overlay; check the **Fill with 50% gray** box.

- Go to **Filter, Noise** and select **Add Noise** - a good point to start from is 15%.

- Now add the Gaussian Blur to blur the noise a little – go to **Filter, Blur, Gaussian Blur.** Make it a blur of 2.5 pixels.

These tips are designed to help you get more out or what is undoubtedly the best photo editing software in the world. This is by no means definitive and there is so much for you to learn. In the next chapter I am going to show you how to create an HDR style in Photoshop by using layers.

Andrew McKinnon

Chapter 10

How to Get HDR Style Results in Photoshop by Using Layers

There is currently a good deal of interest in HDR, or in processes that are like it, but what exactly, is HDR? In a nutshell, it is all about taking a series of photos, using a tripod, at a number of different exposures; you then let a very clever piece of software, like Photoshop, put them all together, merged into one image that is apparently perfectly exposed. There are other pieces of software that will do the job, but as this book is about Photoshop, and it is undoubtedly the best, that's the one I am going to talk about.

Now, once this image has been put together, you have to decide if it looks right. Does it look nice? Some images will look amazing but others really won't look any different, or they will look downright awful. For some people, it is merely a case of using the process because it is there, not necessarily because it is needed. The idea of retouching an image is to improve it significantly, but for this to work it has to look seamless; amazingly good, perhaps too good to be true, but with absolutely no sign that any manipulation has taken place.

The process I want to take you through with this chapter is essentially the same, but it will provide a far more realistic result. To begin, you are going to need a nice sturdy, good quality tripod. This will be much easier if you use a DSLR camera, but you can use a simple point and shoot, provided you are able to adjust the exposure manually.

1. Mount the camera securely on the tripod and compose your image how you want it. Make sure your camera does not move while you are taking the images. If you have a built in timer on the camera, use it, or buy a

timer – they are not expensive. The reason for this is, when you take a photo, no matter how much you try, your camera will shake, even if only slightly and the result will be a blurry image.

2. Each situation is different because the subject and lighting will be different. Let's say you are going to take a photo that contains water, rocks and trees with a nice sky. The ideal situation would be to take one shot of the water exposing it at 4 seconds on f22. Then take another one, exposing the trees and the rock face for 1 second at f22. For the third image, expose the sky for ¼ second at f22. If you can, keep the f-stop constant. Because you are using a tripod, you can shut down the f-stop/aperture, which will give you the maximum depth of field.

3. Now that you have your images, it's time to turn to Photoshop. You can use any version of Photoshop provided it includes Layers. Download the images onto your computer and choose the exposures that you are intending to use. Open those images in

Photoshop and display them all beside each other; your Layers palette should be open to the side. For the purposes of this tutorial, use the darkest layer as a base and then choose the middle exposed image. Go to the Layers palette and click/drag the Layer icon – drag and drop it into the darkest image. Now choose the lightest image and repeat that process. You can have as many images as you want; simply repeat the process until all of your exposures are on one image. Obviously, the more you use, the longer it is going to take to combine them and the more complicated it gets. With this in mind, do choose how many exposures you use carefully. In all honesty, three or four should be sufficient unless you are working with a complicated subject.

4. When you have done all of that, click on the darkest image; the one that you have been dragging all those layers onto. There should be three layers in the palette now. Close down the other images, as you don't need them anymore. What you are left with is one image

that has a number of layers – each one composed of the same shot with different exposures.

5. You are not able to manipulate the background layer fully so choose that layer and duplicate it by using the options at the top of the palette. You should always get into the habit of duplicating your original layer when you are in Photoshop, just so your original remains untouched – vital in case things go horribly wrong!

6. Now click the eye icon – you will find it on the left side of the Background layer. This will render this layer invisible – you won't need it anyway, it is just a backup. If you want, you can give all your layers names at this stage to make them easier to manage. It isn't essential but it is a good practice to get into, especially if you are working on complicated images that have a large number of layers.

7. So, you have three layers – what are you going to do with them? First, you are going to mask out a section of each layer. This will let elements of the lower layers to come through eventually and this is what will give

you one image made from three. We'll start with the layer that is the lightest exposed. Go to your layers palette, select the top layer, which is the lightest one, and add a layer mask. Do this by opening the Layer menu, located at the top of the screen, and clicking on Layer Mask/Reveal All. If you want to know a quicker way to do that, just click on the small-circled icon and it will do the same thing.

8. You do not want too hard an edge, so choose the brush tool to create the mask manually. Go back to the layers palette and ensure that the Mask section is selected (don't get muddled with the image icon) – the Mask icon has a broken edge in black, showing that it has been selected. Make sure the color is on black. If it isn't, you can click on the color square at the top and change it to 100% black. Choose the brush tool you want and you are now ready to mask.

9. Now you are going to use this tool to paint with, making a mask that shows some of the image below. You need to remove the rocks; the sky and most of the

trees from your image so make sure you have opacity set on 100%. Use a large brush to get rid of most of it and use a small brush for going around the edge of the water line. You can zoom in for this part so you can see better what you are doing.

10. By now, the middle layer should be starting to come through. You should also see the Mask icon on the layers palette showing you a preview of what you have just done. Carry on until you are happy with the results. On the next layer I will tell you how to do a more accurate mask, but this is a good way of creating a quick mask.

11. Once you are content with what you have done, go onto the next layer and create a new layer mask. This time, you are not going to use the brush tool on its own; first, you need to make your selection, as the mask needs to have more definition around the rocks. What you are going to do with this one is mask the sky out so that it comes through on the darkest layer. There are a few ways to do this, but the best way, if you

have a good difference in color between the sky and the rocks, is to use the Magic wand tool. Set it at a tolerance of 25 and, holding down the Shift key, select bits of the sky until there is a line of marching ants around the rocks – an unbroken line. The chances of you managing to select all bits of the sky are low, but that doesn't matter at this stage. The most important thing is that there is an unbroken line around the rocks.

12. You can use the Lasso tool to select the rest of the sky; hold down your Shift key and go around the bits that are not selected so that you have a lasso selection around the entire area you want to mask. Before you mask, add a feather on the selection – only a small one. Even though you want your line to be crisp, it is a very rare occasion that you don't need at least a little feathering. To do this, open the Select menu, found at the top of the screen, and choose Modify/Feather. Aim for around three pixels as a starting point – you will know very quickly if this is not enough, or too much. If it isn't right, just go back to the feather

palette and change it. Each image is different and how much resolution is in it will partly determine how much feather is needed.

13. Now that you have your marching ants around the sky, with a feather of three pixel (or thereabouts), you can choose the Mask icon from the layers palette, on the middle layer. The best way to go from here is to use your brush tool again as it will give you better control. So, go and select the brush tool and do the same as you did before. This time though, the selection has made things a lot easier for you.

14. At this point you should be able to see the entire picture starting to form, with parts of all the layers coming together to create the finished picture. Carry on masking until the entire selected area is filled. Because you have added a small feather, the more you go over specific areas around the edge with the brush tool the more it will begin to creep out. Continue until you are happy, then go back to your Select menu, and deselect the marching ants.

15. Your image should now be visually pretty much done. You might want to add a touch up here and there to be completely happy with it, but don't go overboard. If you have a dirty sensor on your camera, you may find sensor marks on the image – use the Spot Healing tool to eliminate those. You can also make changes to the hue, contrast and saturation. Clone out anything you do not want to be in the picture, such as a bit of rubbish that may have got in the shot. You can also use the burn tool to edge the rocks if you want.

16. Once you are totally happy with it, save your new image. Keep a copy of the layered file in case you want to make any changes later on down the line. Save that as a .tiff or .psd file, keeping the layers intact and make sure the file name indicates that it is the layered version. When you have done this, (and remember where you saved it) you can go back to the Layers palette for the final time and select Flatten Image

17. Now you can save the final image in the format you want to use it in. If you are short on hard drive space,

you probably want to stick to .jpg. So, there you are, you have now finished an image using layers to create a manual HDR finish.

I hope this tutorial has helped you, even if only a little bit. Once you can do this, you can play around with the tools and find out for yourself what effect everything has. Experiment to refine your finished image and see what you can create.

Andrew McKinnon

Chapter 11

5 Tips for Shooting and Creating Successful HDR Photos

So, how do you create the perfect, most successful HDR photos? It is a commonly asked question, but I must make it very clear that HDR photography is a real battleground, one of those never-ending ones and there will always be arguments for and against the use of HDR.

While it is always fun to get involved in such a debate, for the purposes of this chapter, let's forget about whether it should be classed as a valid form of photography, or not, and train our focus on giving those of you that wish to learn a new technique, a few tips on how to get it right.

Andrew McKinnon

Tip 1 – Always Use a Good tripod

In all honesty, I shouldn't even have to mention this but, there you go, it has to be said. You would probably be very surprised at the number of photographers who don't use one and suffer later on. A tripod will let you stabilize each of your images – some of them may be shot at long shutter speeds – but, if you really want to capture the whole dynamic range of the scene you are shooting, you need to shoot multiple exposures and it is very important that all of the frames perfectly line up. Using a tripod will ensue that all of the frames are identical – the only thing that is different will be the exposure times. No matter how hard you try, if you don't use a tripod you will get camera shake and your images will be blurred; they will also not line up.

Tip 2 – Don't Map a Single Exposure and Pass it off as HDR

This is a frequent occurrence and while it may be a good way of getting more out of one exposure, it really is not HDR and should not be called as such. Yes, you can use Light Room to create three images – one under exposed, one neutral and one that is over exposed – using one RAW file, and then

merge them to create an HDR image. It isn't the same as shooting those three individual images though and you really will not get the detail you need from just one.

Why, I hear you ask? It's simple really; when you take an exposure using a given set of exposure values, you are only recording the data within that range – nothing more and nothing less. It doesn't matter what you do with that one exposure afterwards, the image that has been captured is not going to change – all you are changing is the way the data is output.

However, when you shoot three or more images, each one at a different exposure, those images will all have different data in them, all data that you can pull into one image, giving you a high dynamic range image. The more images you take at different exposures, you more data you have to pull from. That said; do bear in mind the law of diminishing returns. That means that, at some point, adding more data won't improve your image and it won't be worth it.

Tip 3 – Learn to Know When You Need to Use HDR and When You Don't

There are those that insist on using HDR on every single image they take, but really and truthfully, you do not need to do this. HDR stands for High Dynamic Range so if the photos you are taking are of a scene where you have reasonably even lighting, from the shadows to the highlights (your scene will fit on the histogram evenly, without having anything clipped at either end), you do not need to go down the HDR route. A good camera is perfectly capable of pulling sufficient detail out of the highlights and shadows to entirely cover the scene with a single exposure. It also isn't really worth trying to HDR an action shot, where the subject is moving, because it won't look right in the tone mapping.

Use HDR when you are shooting images at sunrise and sunset, especially if you are facing the sun. You can use it when you are photographing in the middle of the day, or when you are photographing architecture, or man-made objects. HDR is really best used for bringing out detail so use it when your images require that.

Tip 4 – Make Sure You Use a Decent Tone Mapping Program

Once you have your set of images, you need to put them together in the best way you can. While there are loads of really good programs to choose from, some free, some paid, do make sure that the one you use is good. Photoshop has a tone mapping plugin that I would recommend you use, rather than going to the expense of using a separate piece of software – it makes sense to keep it all together.

Tip 5 – Do Keep the Urge to Go Bigger Under Control

This is the point at which HDR becomes something of a touchy subject. There are those who say that their particular style is to go overboard, creating something that is surreal, while others argue that they are running the photography world by creating images that are full of saturation and odd lighting.

It is very easy to get carried away when you are tone mapping, but if you are aiming to recreate exactly what you saw when you shot the image, the best thing to do is remember to tone things down a bit before you go ahead and

process the images. Do watch out for the halo effect that is often seen around tree lines as well.

This is by no means an exhaustive list of tips on successful HDR photography; they are, however, a decent way to start on the right path to capturing your very first HDR images.

Chapter 12
Attractive Text Effects for Photoshop

Photoshop is definitely one of the most versatile and user-friendly photo-editing software available in the market. However, the use of Photoshop is not only limited to photographs and photography, you can create and use many interesting text effects in Photoshop to use in your projects and files. You can create interesting effects that will catch the eye of the youth as well as the old generation. Making text effects is not rocket science and anyone with a little knowledge of Photoshop and a little artistic skill can create cool effects easily. In this chapter, you will find some tutorials to create stunning text effects. You can manipulate the tutorials according to your wish, and when you are

experienced enough you can even plan and create your own new text effects right from scratch.

Textception

In this tutorial, you will learn how to use text in Photoshop as a container for other text. You must have seen this effect used in books, comics, or movies. It is popular amongst bloggers as well. In this effect, a long paragraph is often fitted into the shape of a single alphabet:

1. Open Photoshop and go to **File** menu to create a new document. You can choose any size or resolution. The background contents option should be changed to white.

2. When you have created a new document, select the **Type** tool. You can do it with the keyboard shortcut **T** as well.

3. Choose any font of your choice, however, it is better to choose a font with thick letters such as Arial Black.

4. Now type any letter in the document.

5. Use the **Free Transform Resize** option and resize the letter to the desired size. To keep the letter in perfect shape press and hold the **Shift** key while resizing it.

6. When you have resized the letter, click on the **Type** tool once again and then right click on the document. A menu will appear.

7. Select **Create Work Path** from the menu that has appeared.

8. You will see an outline around the letter now. If do not see the outline go to the **Layer Palette** and then click on the eyeball i.e. the visibility icon. The letter will now become invisible and the outline visible.

9. Left Click inside the outline. Try moving the mouse around the outline and you will notice that the cursor changes into an **I** with a dotted circle. This indicates that you can now type in the outline.

10. Adjust the font size and shape, or font according to your needs and then select **Justify** from the **Paragraph** menu.

11. Start typing and fill up the letter as per your need. The text will directly conform to the shape of your letter and thus you will create a very interesting effect with ease.

12. Type until you have filled the whole of the text and then click on the **Checkmark** so that your text gets accepted. This checkmark is present in the option bar.

13. Hide the outline by using the keyboard shortcut **Ctrl + H** and save your document.

14. You can create other letters or a complete sentence by manipulating this tutorial.

Glossy Text

You can create interesting glossy and realistic text effects through this tutorial. To make it more attractive and realistic a shadow is added as well.

1. Start Photoshop and create a new document. You can choose any size and background, but an 800 x 600 canvas with a textured background is recommended.

2. Choose a font type of your choice.

3. Type your desired text and select it.

4. Go to **Layer**, select **Layer Style**, and finally click on **Drop Shadow**. Play around with the settings in the menu. Adjust the contour maps, the blending mode, and the gradient overlay. Click **OK** when the desired effect is achieved.

5. To add a perspective press **Ctrl** and click on the text layer. Now create a new layer under all of the layers. You can do this by pressing **Ctrl+ Shift+ N**. Fill the selection with black and then deselect the text by pressing **Ctrl + D**.

6. Apply **Motion Blur** to the layer with an -80 degrees angle and 38 PX distance. Slowly drag this layer down a little so that it creates a shadow like effect for your original text.

Andrew McKinnon

7. Save the document.

Cool as Ice Text Styles

This tutorial will help you create ice like text effects that can be used for children's projects etc. This is an intermediate tutorial, so follow it carefully to avoid mistakes.

1. Start Photoshop and create a new document of any size.

2. Begin with a background gradient. For example, use a **Radial Gradient** in **Blue** shades.

3. Now we need to add a starburst effect in the background. To do this go the **Shapes Palette** and choose the **Starburst** icon.

4. Create a new white layer. Draw the shape. It should be large, white, and centered.

5. Change the **Opacity** to 9-10% and then set it to **Overlay**. Select a large soft brush and erase a tiny part from the center. This will create a soothing faded effect.

6. When done select the **Type** tool and choose a desired font style and size. Now type in your content.

Golden Text

Through this tutorial, you can create Golden text that can be used in a variety of projects. This tutorial can also be used to practice Layers and Layer Styles.

1. Start Photoshop and create a new document of any size. Apply a **Layer Style** to the background layer.

2. Add a black to brown or dark brown **Gradient Overlay** to the document.

3. Create a new layer. Select **Filter, Texture** and under Texture—**Texturizer**. The foreground color should be white while the background color should be black.

4. Change the **Blend** mode to **Multiply**.

5. Now select the **Type** tool and select the font and font size of your choice. Type your content.

6. Create a **Gradient Overlay**.

7. Now add a **Stroke**. Select the **Gradient Fill Type**. The **Gradient** will vary according to the font, so experiment and select the one that looks good.

8. Now add the **Bevel** and **Emboss** effects. Play around with the effect for the best possible look.

9. Add a **Shadow**. Manipulate the **Values** until you achieve the desired effect.

10. If you change the **Gradient** color from **Gold** to **Silver**, you can create a silver text effect as well.

Moonlight Text Effect

This is another glossy text effect that can be used to give your text moonlight like shine. It is perfect for amateurs as well as intermediate learners. Paired with a beautiful font, this effect can surely enhance your simple banners and projects.

1. Start Photoshop and create a new document. The document can be of any size.

2. Using **Radial Gradient** create background. Dark colors will enhance your text so choose black. Be sure

to create the gradient from the center of your document.

3. Create a new layer and insert your text.

4. Select your text and go to blending options.

5. Now adjust the **Drop Shadow**, **Outer Glow**, **Inner Glow**, and **Gradient Overlay**. Adjust the setting until you see moonlight like shine. The values will be different for different fonts.

Starry Text

This effect is useful to create astral text.

1. Start Photoshop and create a new document. The document can be of any size.

2. Select #1a142c color and fill the **Background**.

3. Now create a new **Layer** and name it **Glow**.

4. Select the **Elliptical Marquee** tool and draw an ellipse in the center of the document.

5. Fill it with #6d56b2 color.

6. Press **Ctrl + D** to deselect the ellipse.

7. Go to **Filter** menu and select the **Blur Option**. Select **Gaussian Blur** from the drop down menu and set the radius to 28.

8. Select the **Glow** layer and reduce its opacity to 70%.

9. Select the **Horizontal Type** tool and the type your content. If you are creating a single word then just type in the first letter of the word.

10. Double click the text layer. Change the stroke size to 1 and the position to inside. The color should be changed to white.

11. Select the **Gradient Overlay** option and create a gradient using two suitable colors.

12. Select the outer glow and then turn the opacity to 70%. Change the size and color according to your desire.

13. Right click on the text layer and then **Copy** the **Layer Style**.

14. Create a new layer right below the text layer and then add the next letter of the word.

15. On this layer **Paste** the copied **Style**.

16. Repeat.

17. When done add another **Layer** below all the text layers and name it **Star**.

18. Select the **Brush** tool and then select the star brush. Adjust the size accordingly.

19. Change the fill value to zero.

20. Now add stars in the document. Change the size if you want different sized stars.

21. When desired effect is achieved save the document.

Simple and Useful Text effect

This text effect is not only simple but is also very versatile. The tutorial is also a great beginners tutorial to understand the nuances of Photoshop.

1. Start Photoshop and create a new document of any size.

2. Click the foreground swatch and enter #c07325 in it. Now click **OK** and press **Alt + Backspace**. This will fill the layer with the foreground color.

3. In new **Layer**, change the foreground color to #a73e43. The process is explained in the second step. Now select the **Type** tool.

4. Click on the **Window** menu and select **Character** if you cannot see the **Character Palette**.

5. Select your desired font. The color in the **Character Palette** should be set to the foreground color.

6. Now select the **Type** tool and type your content.

7. Right click on the new text layer and then choose **Blending Options**. A dialogue box will be opened.

8. Select **Stroke** in the above dialogue box and now adjust the size, positions, **Blend Mode**, **Opacity** and all other options according to your taste.

9. Now adjust the **Outer Glow** layer style. In settings, change the mode to **Normal**. Next increase the opacity to 100%. Change the color to black. Adjust the size as well as spread according to your desire. It is highly important to keep an eye on the document while you do any adjustments. Reduce the range to 1% and click **OK**.

10. Press and hold the **Ctrl** key and click on the layer icon in the palette.

11. Go to **Select** then **Modify** and finally **Contract** from the main menu. Adjust the pixels according to your desire; a six or seven pixel number will suit all of the commonly used fonts. Press **OK**.

12. Add a layer above the text layer. Rename it **Accent** and then go to the **Tools**. Change the **Foreground** color to #6e252e.

13. Fill the new layer with the color by pressing **Alt + Del**. Now press **Ctrl + D**.

14. Click on the text layer in the palette. Duplicate the layer by pressing **Ctrl + J**. Rename the **Text** layer to **Text** and the duplicate layer to **Text1**.

15. Now select the **Text** layer and then double click on the layer style icon that can be found in the layer palette.

16. Select **Outer Glow** and then change the color so that it matches the background. Click **OK**.

17. Now click on the **Text1** layer. Right click on the layer style icon and then click on **Clear Layer Style**. Click on the red swatch in the **Character Palette** and then drag the circle to the upper left hand corner. Click **OK**.

18. Click on **Move** tool and then press and hold **V** key. Now with the help of the **Arrow** keys move the text on the Text1 layer to the right and down until the desired effect is achieved.

Chapter 13

Advance Photoshop Tutorials

In this chapter, you will find many advanced tutorials that will help you to unleash the power of Photoshop. These tutorials will also help you to create interesting effects and will help you to improve your photographs, and create photographical masterpieces.

Image Cropping

Often when you are trying to resize a picture to a fixed or standard size the image gets distorted or ruined. There is no easy way to resize the image without ruining it so the best option here is not to worry about resizing at all, instead you should consider cropping the photo. Photoshop's cropping

tool is a versatile and high-end tool that will help you achieve the desired results with ease, and without distorting your image.

1. Start Photoshop and import your image to the workspace.

2. Go to the **Tool Palette** and select the **Crop** tool. You can also use the keyboard shortcut **C**.

3. In the **Options** bar, insert the dimensions that you need. The dimensions should be exact. For instance, if you want to crop the image to 8 by 10 inches insert the appropriate numbers in the boxes. The numbers should be followed by 'in' which stands for inch.

4. Now click inside your work document and drag out the crop border. Remember, everything out of the box (the dark region) will be cut away from your image, and only the things in the box will remain, so crop carefully. The shape will be restricted to 8x10 inches.

5. When you get the desired crop, press **Enter**. The image will be cropped. You can now print the image.

Transform Selection

Sometimes you might want to crop a photo to a certain size without changing the aspect ratio of the image; tweaking some settings in the image size dialogue box often does this. However, you can easily do the same thing by using the Transform Selection option of Photoshop.

1. Start Photoshop and upload the image that you want to crop.

2. Select the entire photo by using the keyboard shortcut **Ctrl + A**. A selection outline should appear around the photo now.

3. Go to the **Select** menu and select **Transform Select** from it.

4. Now press and hold the **Shift** key and grab any of the handles that are around the image with the mouse pointer. Crop the image until your desired effect is achieved.

5. When your desired result is achieved, press **Enter**.

6. Now you need to crop the image. Select **Crop** from the **Image** menu and it will automatically crop your selection.

7. Press **Ctrl + D** and save the image. Your image is ready to print.

Batch Resize

If you are a photographer and blogger, you probably upload your photography to your blog all the time. However, the size of the images shot with the help of a DSLR, or a good quality Point and Shoot camera is often quite large and hard to upload. To reduce the file size you need to resize your images, however, resizing each image one by one is a time consuming task. No worries, in this tutorial you will learn how to resize a batch of images in one go so that you can upload them online with ease.

1. Start Photoshop and create a new document.

2. Go to **File** menu and choose **Scripts**. Now select the **Image Processor** option from the menu. A dialogue box will open.

3. In the dialogue box upload all the images that you would like to resize, you can also select a folder to resize as well. Next to that, you will also find an option to choose all the subfolders in the folder that you have selected.

4. Now choose a location where you would like to save your resized images. If you choose the **Same Location** option then Photoshop will automatically create a **New Folder** and save your resulting images in it.

5. Next, choose the file type. If you are converting the files for use on the web, it is recommended to choose JPEG. Set the **Quality Range** to 4 or more, if desired. Click on **Convert Profile to sRGB** for vivid images. Click on the **ICC Profile** checkbox as well.

6. Select the **Resize to Fit** checkbox and then enter the desired width and height for your image. All of your images will be resized to your chosen size without any distortion.

7. If you want to save the images in many forms and sizes all at once you can do that too by clicking on the appropriate checkboxes.

8. Click **Run** and wait for the process to end.

Straightening Images with Measure Tool

Clicking straight photos without a proper tripod is a difficult task and not many can do it perfectly, hence you may often find that your beautiful pictures are short of being masterpieces just because they are crooked. Photoshop has many tools that can be used to help you in your Photo Straightening endeavor, but the best one is definitely the Measure tool. The Measure tool is accurate because it does not depend upon guesswork. It is also easy to use and can do the job in no time.

1. Start Photoshop and create a new document. Upload the image that you want to straighten.

2. Go to the **Tool Palette** and select the **Measure** tool. It is in the drop down menu in the **Eyedropper** tool.

3. Click and drag the tool around the thing that you want to be straight.

4. When finished, you will see the angle of the line that you have drawn in the **Options Bar**. Photoshop will now use the angle to calculate the angle of straightening.

5. Open the **Image** menu and select the **Rotate Canvas** option. Select **Arbitrary** from the menu. A dialogue box will appear.

6. Click **OK**. Your image will be straightened.

7. Select the **Crop** tool from the **Tool Palette** and crop the image to cut out the newly created white space.

8. Save the image.

Vivid Color Images

Vivid and brightly colored images look not only stunning, but also quite beautiful. However, shooting such vivid and bright images is a difficult task especially with a regular point and shoot camera, but you can always use Photoshop

to create such images. In this tutorial, you will find 6 quick and easy steps that will help you turn you simple and sober pictures into bright and vivacious ones.

1. Start Photoshop and click on new document. Upload the image you want edit.

2. Create a **Curve Adjustment Layer**. Right click on this layer and then choose **Blending Option**. A dialogue box will appear.

3. In the dialogue box change the blend mode to **Soft Light** and then decrease the **Opacity** so that it comes to 80%.

4. Click on the **Advance Blending** section and then change the **Fill Opacity** to 80% as well.

5. Now go to the **Blend If** section and press and hold the **Alt** key. Shift the right hand part of the dark slider until you see 0/50. Keep an eye on the document while you do so.

6. Adjust the **Curve of Adjustment** according to what you want and save the image when done.

Vivid Black and White Images

Black and white photography is a serious art and shooting monochromatic photos is perhaps harder than color shoots. Like color photographs you need to be conscious of the color in your images and click accordingly, hence everyone's black and white snap of the same thing will look different. You can make stunning and professional looking black and white photographs out of color images using many methods some of which are given below. Some of these are easy to use while some are difficult, but offer full control. Choose your technique according to your desire and the time you have.

Channel Mixer

This is one of the best tools to create black and white photographs as it is used to manipulate the three-color channels. Being the best tool, it is also quite difficult to master, but with enough practice you will achieve wonderful results in no time.

1. Start Photoshop and create a new document. Upload your image.

2. Go to the **Image** menu and click on **Adjustments**. In the sub menu click on **Chanel Mixer**.

3. Click on the **Monochrome** checkbox in the lower left corner. Set all the colors to 100%.

4. Slowly adjust each of the three colors, one by one, until the desired result is achieved. You can also try inputting negative values; however, the sum of red, green, and blue channels should always be 100% to maintain a constant brightness. You can also do this by using the **Constant** bar at the bottom of the dialogue box.

5. When done click **OK** and save the image.

Hue and Saturation

This technique is versatile yet easy to use. However, the setup process for this technique is lengthier compared to the previous one.

1. Start Photoshop and create a new document. Upload your image.

2. Go to the **Layers** menu and choose **Hue and Saturation** from **New Adjustment Layer**. Repeat. Now you have two **Hue/Saturation Layers.**

3. Select the top adjustment layer and change the blending mode to **Color**. Change the saturation to -100.

4. Select the bottom adjustment layer and adjust the **Hue** slider until the desired effect is achieved.

5. When done, flatten the image and save it.

Lightness Channel

This is a superfast and super easy technique to convert color photographs into black and white ones.

1. Start Photoshop and create a new document. Upload your image.

2. Go to the **Image** menu and select **Lab Color** from the **Mode** menu.

3. Click on the **Lightness** channel. Next delete both A and B channels. Now only the lightness channels remain.

4. Adjust the channels and then save the image.

Desaturation Color Technique

This is the easiest method to convert a color image into a black and white image, however, the result of this method is often inadequate.

1. Start Photoshop and create a new document. Upload your image.

2. Go to the **Image** menu.

3. Click **Desaturate**.

4. Save your image.

Vivid Image with the Help of Black and White Technique

Although the previous tutorial on vivid images is a highly sophisticated one, this one will help you to achieve great

results as well. In this method, the image is converted to black and white temporarily to edit the colors.

1. Start Photoshop and create a new document. Upload your image.

2. Go to the **Image** menu and select **Adjustments**. Now choose **Black and White**. A dialogue box with multiple options will appear. Do not adjust or change any of the settings and click **OK**. Your image will be converted to black and white instantly.

3. Now go to the **Image** menu once again and select **Levels** from the **Adjustments** sub menu. A dialogue box will appear.

4. Adjust all the three triangles at the bottom. Do this until the best brightness and contrast settings are achieved.

5. When the desired effect is achieved click on **Save**. Then click **Cancel**.

6. Now click just below the **Black and White History** option in the **History Palette**.

7. Go to the **Image** menu and select **Levels** from **Adjustments** again. Now click on **Load**. Select the **Levels** file that you made earlier.

8. Adjust the image if you see any error.

9. Save the image.

Black and White+ Color Splash

Often people want to display some color in a black and white photograph. This not only looks interesting, but has artistic value as well. In this tutorial, you will learn how to create such an image. The simple method used for this effect is as follows.

1. Start Photoshop and create a new document. Upload a bright and vivid color image.

2. Create a copy of an **Image Layer**. Right click on the layer and click **Duplicate Layer**.

3. Select the first layer and convert it into black and white by using any simple conversion option available.

4. Go to the **Tool Palette** and choose **Eraser**. In the **Options Bar** set the **Hardness** to 100%. Select the size according to your need.

5. Move over to the photo and slowly erase the area that you want to convert into black and white, leaving the desired colored ones intact. Use zoom and adjust the size of the eraser when working on the details.

6. Change the opacity and fill percent of the colored layer to 80%.

7. Flatten the image and save.

Cool as Ice Text Styles

This tutorial will help you to create an ice like text effect that can be used for children's projects etc. This is an intermediate tutorial so follow it carefully to avoid mistakes.

1. Start Photoshop and create a new document. Upload a bright and vivid color image.

2. Go to the **Tool Palette** and select the **Polygonal** lasso tool.

3. Use the **Polygonal** lasso tool and select the area of the image that you want to be colored. Right click on it. A drop down menu will appear. Click on **Layer via Copy** in this menu. A new layer will be created.

4. Go back to the previous layer and select it. Turn the image into black and white using your favorite technique.

5. Adjust the opacity and fill level of the color image.

6. **Flatten** and **Save**.

Using Match Color Command

This option lets you match the colors of an image to other colors of another image using the Match Color Command. However, this option is only available in CS and later versions.

1. Start Photoshop and create a new document. Upload your image.

2. Press **Ctrl + J** to create a new layer. Name this new layer 1.

3. Go to the **Tool Palette** and choose a selection tool, you can choose the **Lasso**, the **Pen** or any other tool. Using the tool, select the object you want to change the color of.

4. Now create another document and upload your image into it.

5. Select another selection tool and select a large area of the color you want. The selection need not be precise, but try to get as many as shades of the color from the image, including all the highlights and the shadows.

6. Go to your original image and bring it into focus.

7. Go to the **Image** menu and choose **Adjustments**. Under the **Adjustments** menu, select **Match Color**. A dialogue box with many options will appear.

8. In the bottom half of the dialogue box (Image Statistics section) you will find an option called **Source**. Click on the arrow against the right of the option and choose you second image. This is your source image.

9. Next to the **Source Image** option, there are two checkboxes, **Use Selection in Source to Calculate Colors** and the **Use Selection in Target to Calculate Adjustment**. Check both the boxes.

10. Click **OK**.

11. To adjust the shadows and highlights of the selection to make it more authentic go to the **Layers Palette** and click on the **New Adjustment** button.

12. Select **Levels**.

13. A dialogue box with a histogram with three sliders at the bottom will appear. Adjust the sliders until you achieve the desired effect. Keep an eye on the image when you manipulate the sliders. When done click **OK**.

14. In the **Layers Palette** go to the **Blend Mode**, click on the arrow next to it. Select **Lumosity** from the drop down menu.

15. Press **Ctrl + D** to deselect the image.

16. Flatten the image and save.

Best of Both Worlds

If you are a budding photographer then this tutorial is for you. Often while doing studio photo-shoots you feel the need to combine two images to form a brilliant composite image without any imperfections. To do this seamlessly and in a hassle free way you need to use some adjustment masks and other tools of Photoshop.

1. Start Photoshop and create a new document. Upload both the images that you want to use.

2. Select the **Move** tool from the **Tool Palette** and drag it onto the first image then drag the image in to the second document. Hold the **Shift** key to keep it aligned with the second image. Rename the first image **Top** and the second one **Bottom**.

3. Select the **Top** layer. Press and hold the **Shift** key and then select the **Add New Group** icon from the **Layer Palette**. Now press and hold the **Alt** key and click on the **Add New Layer Mask** icon. You will see

a black mask like layer spread over the complete group.

4. Toggle the ink to white; you can do this by pressing the **X** key. Now select a soft edged brush and change its opacity to 100%. Brush the part of the image that you want to add in the second image.

5. Select the **Move** tool and zoom into the area. Align the **Top** layer so that it aligns with the **Bottom** layer.

6. The new part from the **Top** image will probably be larger or smaller than the **Bottom** image. To adjust it go to the **Edit** menu and select **Free Transform**. This should be done on the **Top** layer while holding the **Shift** key. Resize the image. Press **Enter** when the desired results are achieved.

7. When the part is in proportion as well as in the correct position, clean the background area. To do so use white on the layer mask and blend both the backgrounds. To do this, use a soft brush with 30% opacity.

8. Use the layer mask once again to edit out any errors.

9. Use a soft brush with 30% opacity on the layer mask to blend the new part with the bottom image.

10. Click on the **Top** layer and then select **Calculations** from the **Image** menu. Change both the channel options to green.

11. Change the blending mode to **Screen** while the result to **Selection**. Now click **OK**.

12. Add a **Curves** adjustment layer from the **Layers Palette**.

13. Click on the **Curves** diagram and set both the **Input** and **Output** options to 50%.

14. Press and hold the **Up** or **Down** arrow key to change the tone of the part. Adjust the tone until you achieve the required results.

15. Merge the layers together and save.

Advance Sharpening

Andrew McKinnon

In this tutorial, you will learn to use advance-sharpening techniques that will make your images crisp and suitable for printing.

High Pass

1. Start Photoshop and create a new document. Upload your image.

2. Duplicate the background layer from the **Layer Palette**. Change the **Blend** mode to **Overlay**.

3. Go to the **Filter** menu and select **High Pass** from the **Other** sub menu.

4. Slowly increase the pixel radius until the desired effect is achieved.

5. Select the **Foreground** color from **Tools Palette**. The color picker dialogue box will be displayed. Input 0 in the **Hue & Saturation** fields and 50% in the **Brightness** one. Press **OK**.

6. Paint over the layer to remove noise.

7. Print the image and check whether it needs more sharpening.

8. Change the **Blend** mode of the **High Pass** layer to **Normal**.

9. Go to the **Image** menu and select **Threshold** from the **Adjustments** submenu.

10. Adjust the sliders until the desired effect is achieved.

11. Press **OK**.

12. Select the **Load Channel As Selection** button at the bottom of the **Channel Palette**. Make a copy of the background layer in the layer palette. Drag this copy to the top of all the layers.

13. Turn off the **Visibility** of the **High Pass** layer.

14. Press and hold the **Alt** key and then click on **Add Layer Mask**.

15. Go to the **Filter** menu and select **Gaussian** from the **Blur** submenu. Put a 1.5 PX blur.

16. Select the image thumbnail from the background copy layer. Select **Smart Sharpen** from the **Sharpen** submenu under **Filter**. Adjust the **Amount** slider until the desired result is achieved.

17. Select the uppermost layer and change its **Blending** mode to **Luminosity**.

18. Merge and save.

Chapter 14
FAQs and Troubleshooting

Up to now, we have seen many tutorials, abbreviations, suggestions, tips and tricks related to Photoshop. In this chapter we will look at some of the most commonly observed problems and their solutions. These solutions are easy and quick and will set you on the right path instantly.

How to create High Quality .GIFs in Photoshop?

Not many people know that you can create great quality gifs in Photoshop. It is important to avoid using low-resolution videos. Choose correct dimensions for your gifs as incorrect dimensions will make the gifs blurry. Choose good coloring.

What exactly is a Brush?

The Brush tool was explained briefly in the Tool Palette section; however, there is a slight difference between the Brush and the Brush tool. The Brush tool is a fixed tool while the Brush is one of several templates of the tool. These etchings or stains can be added to a Photoshop document. Brushes were very much in vogue in the past few years however, their popularity has decreased nowadays. You can find many interesting brushes online that can help you to beautify your image. Using the brush is quite easy. To add new brushes to your application first download a brush pack from the Internet. Load the ABR file and now your Brush tool will have new templates in the options bar. You can then use these new brushes according to your wish and desire.

What do you mean by .PSD?

PSD is the file extension for a Photoshop Document. It is a format in which you can save your project in such a way that you will be able to resume your editing. Online PSDs often have different sets of layers including those of hue and saturation, colors, brightness and contrast, curves, gradient maps etc. These layers are preset and thus can be loaded into

your document to imitate an effect. To use a PSD you need to download suitable PSDs from the Internet. Open your image in a Photoshop window and open the PSD in another window. Now you can drag the layers from the layers palette onto your image. You can adjust the layers and can delete them as well. Not all PSDs are wonderful, some might ruin your project, but you can always delete the layers.

What is an action and what does it do?

An action is one of the most important functions of Photoshop. An action is basically a set of effects, or instructions, that are played automatically. Actions can be made, or downloaded from the Internet. To load a new action, first download the action from the Internet and save it on your computer. Now start Photoshop and click on the right corner. Select your action file and then load it. Click play to use the action. It is important to remember that the action should only be used on a visible and flattened image.

Creating an action is quite easy too. Create and edit a picture and then go to the same corner we went to in the previous step. Click on New Set and then New Action. Now click

Record. Then add your layers, filters etc. Whenever you add something, click on the square on the left. Save the action and use it in the future. It should be noted that actions are not perfect and many times the action you recorded will not work according to your need.

Installing Custom Fonts

Photoshop is not only an image editing application, but it has great Text and Caption making capabilities too. To enhance these capabilities you can add new fonts to your computer. Adding fonts is easy; just download fonts from the Internet and then save the file on your computer. Unzip the font and move the font to the following folder C:\Windows\Fonts. Your fonts will be installed automatically. To use your newly installed fonts simply go to Photoshop and click on the Type tool, you will find your new fonts in the Fonts options.

What is a pattern in Photoshop?

A pattern in Photoshop is a kind of a texture file that can be used for the background. Go to Edit and then click on Define New Pattern and then add a New Layer. Click on New Fill

layer and then select Pattern, your pattern will repeat itself i.e. it will tile itself and will thus create a background. For a perfect background your pattern needs to be symmetrical. You can download many patterns from the Internet or create your own as well.

How to unlock gif?

If you have opened a gif in Photoshop and are trying to move it or drag it then it is highly possible that you are not able to do so. This is because Photoshop has locked your gif by changing the format to indexed color. To unlock your file change the mode once again to RGB from the Indexed Color. You can do this from the Mode option in the Image menu. Now you can drag and move the gif around without any problem.

Best place to find free fonts online.

One of the best sites to find free fonts online is Dafont. You can find fancy, funky, weird and all kinds of fonts on this site. Please check the copyright status of the fonts before downloading. If you plan to download fonts from other sites, please install and update the antivirus software on your

system. It is also a good idea to check the reviews of a particular site on the Internet before downloading anything from it.

Can you draw a straight line with the help of a brush?

You want to draw a straight line, but do not want to select a new tool. So can you do it with the old and faithful brush tool? Yes, the easiest way to do so is by pressing and holding the Shift key while drawing the line. You can use the same method while using the eraser, clone stamp or any other tool as well.

Why cannot I define a Brush Preset?

So you are trying to Define Brush Preset but the option is grayed out. This is a common problem, which generally happens because the image you are trying to use as a preset is over 2500 x 2500 pixels. Reduce the image to 2500 x 2500 pixels and you will able to set the preset once again.

Where did my panels go?

You are trying to create your next masterpiece and are excited about it when suddenly something happens and all

of your panels disappear. Where did they go? The culprit here is the Tab key. A simple brush against the Tab key can make your panels go away, but pressing it again will bring them back at once.

Where is my cursor?

Often while working with a tool your cursor changes shape and simply disappears. This generally happens because you have switched on the Precise Cursor mode. To rectify this simply press the Caps Lock key and your cursor will return to its original shape. You can further change the cursors with the help of the shortcut Ctrl + K.

Bad tools are quarreling with the worker.

You are trying to create a piece of art, but none of your tools seems to work. You simply cannot stain the page. Although the problem is easy to describe the reasons and solutions are many. One of the basic solutions is to check whether your page is selected, if it is press Ctrl + D. If this does not work then go to the Channels Panel and check whether you are working in Quick Mask channel, if yes then select the RGB

or CMYK Channel. Finally try pressing Q key. Your tools will start working once again.

Tabs Tabs everywhere.

You love Photoshop so you decided to update your application, but now everything works in tabs and they are just baffling. This is a frequent problem with many of the old users of any app. To change the interface of Photoshop press Ctrl + K and select the Interface tab. Under this section, you can disable the tabs.

Strange clipboard error is haunting you.

You are trying multitasking, but Photoshop keeps hanging whenever you try to switch. It also gives you a weird error regarding the clipboard. What to do? This is happening because Photoshop is trying to be a Good Samaritan and is helping you to copy its data. Unfortunately, this is causing your clipboard error. To turn this option off press Ctrl + K, a dialogue box will appear. Click on the Generals Tab on this dialogue box and select Export Clipboard. Click OK.

Files do not open in the application directly.

Your major image files are not associated with Photoshop hence you cannot open them directly. To solve this right click (in Windows Explorer) the file you want to associate with Photoshop. Select Open With and then pick Photoshop. Check the Choose Default Program checkbox. Select Always and then press OK. All the files of the current file format will now be associated with Photoshop.

Scratch Disk Error

Your System Drive has become full, your application is running slow, and your computer is working at a snail's speed as well. Whenever you try to perform an action in Photoshop an error appears saying something about scratch disk. The Preference dialogue box can solve this once again. Press Ctrl + K. The Preference dialogue box will appear. Select the Performance tab from the box. Add extra scratch disks under the Performance Tab. Click OK and exit Photoshop. Now go to the Start Menu and look for the disk Cleanup option. Normally you can find it in the System tools sub menu in the Accessories menu. Follow the instructions in the new dialogue box to clean up your system drives.

Zoom Resizes Window

You are trying to Zoom in or out of your document, but it keeps on changing the size of the main window. You will also find the solution to this problem in the Preference dialogue box. Press Ctrl + K. The Preference dialogue box will appear. Go to the General Tab and then select the option called Zoom Resizes Windows. Click OK.

Photoshop is Slow

If you cannot do anything in Photoshop and even the simplest task is taking too long then the best option is to upgrade your RAM or even your PC. However, if these options are not available to you then you can try tweaking the performance of Photoshop from the Preference tab. Press Ctrl + K. The Preference dialogue box will appear. Go to the Performance tab in the box. Under the Performance tab, you will find a submenu in which you can give Photoshop more resources. Keep an eye on the ideal range of the RAM if you want to run any other application with Photoshop. You can also choose to use 100% of the RAM for Photoshop, however no other application will run with Photoshop!

Chapter 15
Keyboard Cheats

In this chapter, you will find some of the most commonly used Keyboard Shortcuts for Photoshop in tabular form. Flaunt your expertise of Photoshop with these easy and time saving shortcuts. It should be noted that most of these shortcuts would do different things in different windows, so it is necessary to try them in various windows. If something goes wrong, you can always delete the recent stat from the History Palette.

- Shift + M Select the Elliptical Marquee Option.

- Shift + L Select the Polygonal Magnetic Lasso Option.

- Shift + W Select the Quick Selection Option.

- Shift + C Select the Slide Tool.

- Shift + I Select the Color Sampler Tool.

- Shift + J Select the Spot-Healing Tool.

- Shift + B Select the Color Replacement Tool.

- Shift + S Select the Pattern Stamp Option.

- Shift + Y Select the Art History Brush.

- Shift + E Select the Background Eraser Option.

- Shift + G Select the Paint Bucket Tool.

- Shift + O Select the Sponge Tool.

- Shift + P Select the Freeform Pen Tool.

- Shift + T Select the Vertical Type Option.

- Shift + A Select the Path Selection Option.

- Shift + U Select the Rectangle Option.

- Shift + K Select the 3D Object Rotate Tool.

- Shift + N Select the 3D Camera Rotate Tool.

- H Select the Hand Tool.

- R Select the Rotate Tool.

- Z — Select the Zoom Tool.

- Ctrl + Tab — Move forward and backwards through all the open documents.

- Shift+ Ctrl + Tab — Go back to the previous document.

- Shift+ Ctrl +W — Close document in Photoshop. Open Bridge.

- Q — Quick way to shift between the Standard mode and the Quick mask mode.

- Shift+ F — Moves backward and forward between the Maximized Screen Mode, Standard Screen Mode, and Full screen

Mode with the Menu Bar.

- Space+ Shift+ F Move between Canvas Color Forward and Canvas Color Backwards.

- Double Click Hand Tool Will make the image fit the size of the window.

- Ctrl + 1 Will magnify the document to 100%.

- Space Bar Will toggle the Hand Tool Temporarily (If you are not in the text-editing mode.)

- Ctrl + Space Bar Will toggle the Zoom In Temporarily.

- Alt + Space Bar Will toggle the Zoom Out Temporarily.

- Space + Drag Change the position of the Zoom Marquee while dragging simultaneously with the Zoom Tool.

- Shit + Enter (Navigator Panel Zoom Percentage Box) This will apply the percentage of zoom and will keep the box active as well.

- Ctrl + Drag (Navigator Panel) Will Zoom in on the area of an image.

- Page Up Move up by one screen.

- Page Down Move down by one screen.

- Shift + Page Up Move up by 10 units.

- Shift + Page Down Move down by 10 units.

- Home Move to the top of the document.

- End Move to the end of the document.

- \ Turn on or off the toggle layer mask.

- Esc Cancel the ongoing process.

- Ctrl + Z Undo the last action.

- Ctrl + A Select all the pins.

- Ctrl + D Deselect everything.

- Shift + Click Select specific areas.

- Shift + drag Move Multiple selections.

- H Temporarily hide selected.

Andrew McKinnon

- Ctrl + Alt + R Opens the refine edge box.

- F Move forward in the Preview Modules.

- Shift + F Move Backwards in the Preview Module.

- X Move between the original image and the selection preview.

- P Move between the original selection and the refined version.

- J Switch on or off the radius preview.

- D Will select the Thaw Mask option.

- E Move between Refine
 Radius and Erase
 refinements Tool.

- Alt + Click on a This will apply the filter
 Filter on the top of the selected
 layer.

- Ctrl + Shift+ Z Step Forward.

- Ctrl + Alt + Z Step Backward.

- W Will open the Warp Tool.

- R Will open the
 Reconstruct Tool.

- C Will open the Clockwise
 Tool.

- S Will toggle the pucker
 Tool.

- B Will toggle the bloat
 Tool.

- M Will toggle the Mirror Tool.

- T Will toggle the turbulence Tool.

- F Will toggle the Freeze Mask option.

- Tab Move through the controls from right (Top).

- Shift + Tab Move through the controls from right (Bottom).

- Ctrl + Shift + Z Redo the last action.

- Ctrl + H Hide the selection and planes.

- Ctrl + C Copy the selection.

- Ctrl + V Paste the Selection.

- Ctrl + Shift + T Repeat the last duplicate action.

- Ctrl + Alt + T Will create a floating selection with the help the current selection.

- Ctrl + drag Will fill the selection with image that is under the pointer.

- Ctrl + Alt + Drag Will duplicate the selection as a floating selection.

- Backspace Delete the last action.

Andrew McKinnon

Conclusion

Congratulations on completing this course successfully. As mentioned earlier, I am sure you must have fallen in love with Photoshop by now. But these are just the basics of Photoshop, it is a much more intricate and interesting program; you can achieve just about anything you want with Photoshop, with almost endless possibilities.

If you really want to unlock the secrets of Photoshop you should not just stick to this book but expand your horizons.

Thank you for buying this book, good luck!

Andrew McKinnon

28461437R00105

Made in the USA
San Bernardino, CA
29 December 2015